OIL PAINTING
EVERY DAY

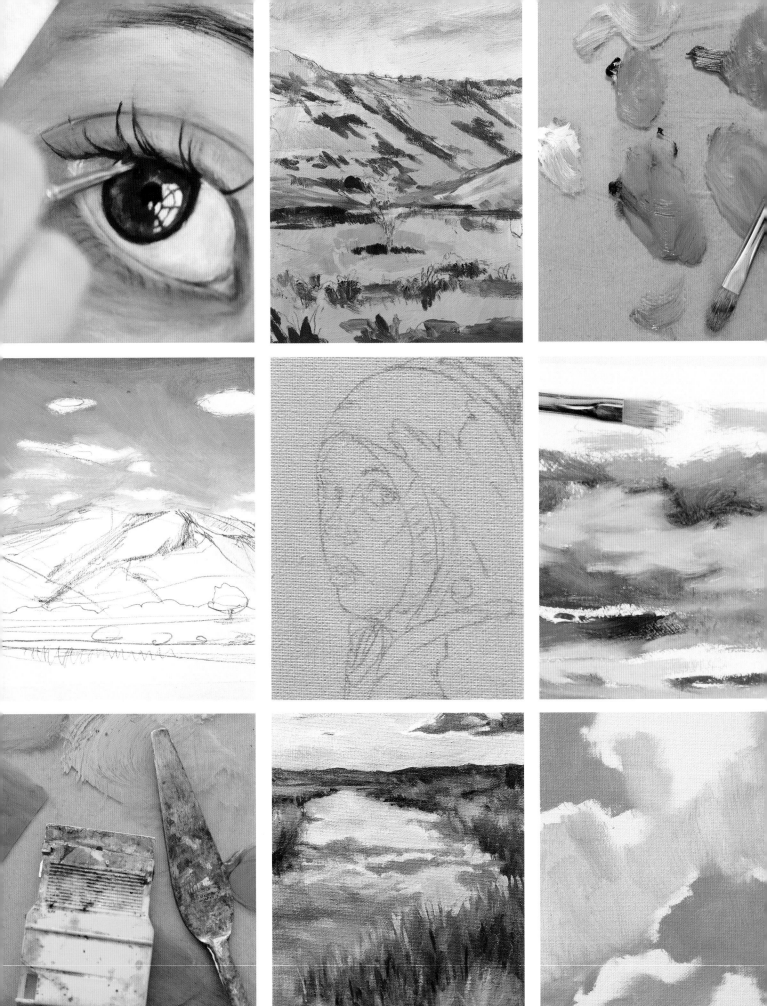

OIL PAINTING
every day

A STEP-BY-STEP BEGINNER'S GUIDE
TO PAINTING THE WORLD AROUND YOU

ROBIN SEALARK

Brimming with creative inspiration, how-to projects, and useful information to enrich your everyday life, Quarto Knows is a favorite destination for those pursuing their interests and passions. Visit our site and dig deeper with our books into your area of interest: Quarto Creates, Quarto Cooks, Quarto Homes, Quarto Lives, Quarto Drives, Quarto Explores, Quarto Gifts, or Quarto Kids.

First Published in 2022 by Quarry Books, an imprint of The Quarto Group, 100 Cummings Center, Suite 265-D, Beverly, MA 01915, USA. T (978) 282-9590 F (978) 283-2742 QuartoKnows.com

Quarry Books titles are also available at discount for retail, wholesale, promotional, and bulk purchase. For details, contact the Special Sales Manager by email at specialsales@quarto.com or by mail at The Quarto Group, Attn: Special Sales Manager, 100 Cummings Center, Suite 265-D, Beverly, MA 01915, USA.

10 9 8 7 6 5 4 3 2 1

ISBN: 978-1-63159-994-1

Digital edition published in 2022

eISBN: 978-1-63159-995-8

Library of Congress Cataloging-in-Publication Data available

Design: Galbreath Design
Cover Images: Robin Sealark
Page Layout: Galbreath Design
Photography: Robin Sealark

Printed in China

Dedication

To Mom, who introduced me
to a paintbrush, and Dad,
who introduced me to the ocean.

CONTENTS

INTRODUCTION

Welcome behind the oil painter's curtain!

HELLO! YOU'VE MADE IT, AND I'M GLAD YOU'RE HERE. Please join me in a step forward as we venture together into oil painting.

I humbly present my trade secrets after a decade of oil painting. It is my earnest desire that you internalize and transform these tools with your own creativity. Art is freeing, challenging, strengthening, and inspiring. The easiest way to learn is by making it.

Think, "I'm ready to use my creativity. No art blocks allowed." Today you are officially a student, an artist, and a creative.

Enjoy your foundational development and my mentorship over these projects. Today we walk beyond the curtain, and through time, you'll explore further artistic depths. Finding joy in creating every day is possible with a healthy, creative practice as your compass. Use this book as a foundational guide and carry my artist's blessing with you. As you grow in craft, style, and artistic habit, remember the inner strength and joy born with each step you invest in process and possibility. Personalize the way you create each day, and let's practice living in a full spectrum of color with oil painting.

Why Use Oils?

Oil paintings radiate in our art history. When I was a younger student, the tool used to create master works drew me in—a vehicle for awe, with a creamy, rich, and vibrant color depth. Oil's slow-drying property allows for seamlessly blended sunset gradients, soft glowing subjects, and dreamy surface texture. While I've worked in a variety of mediums, I hallow the unique abilities of oils and forever return to this magical tool. When used with skill, oils command attention and transport the viewer, blurring the line between painting objecthood and experience.

Here are two important tips for success:

1 Figure out the rules.
2 Make whatever you want.

As a wee schoolchild, I liked to learn requirements. Once I knew what I had to do, I could get to the fun of doing it my way. Entering a hands-on, skill-building creativity class, art and I became immediate friends. Art would teach me, and we surprised each other. A relationship and bond formed.

Tune into yourself as you paint through this book. Your relationship with art is your own. **If you want to alter an exercise, use your own reference photo, experiment with the style, cut out images, paint over my work—do it!** You are both student and artist, so rock on, dear creative one.

1

OIL PAINTING SUPPLY GUIDE

*In this chapter, we'll discuss oil painting supplies and
review basic color theory to prepare you for your creative journey.*

To be an oil painter, you should be equipped with the necessary supplies. In this chapter, you'll discover what you need to begin: useful paint colors, medium, brushes, painting surfaces, and tools. You'll learn how to use these supplies with information and exercises covering basic color theory, brush cleaning, and medium use.

This chapter contains key color-mixing information and skills that should be used to guide future projects. Even if you've used basic oil materials before, I encourage you to review this chapter's color theory lesson and exercise as a refresher and confidence builder for color mixing. This basic complementary color lesson took me years to internalize, but it's simple and critically useful now that I grasp it. Make the lesson an easy grab in your tool belt so you can feel comfortable wiggling outside the formulas of the projects to achieve colorful, personal images, customized to your liking. With simple foundational knowledge, you'll access greater freedom and creativity in personal work.

UNIQUE PROPERTIES OF OIL PAINT

Oil paint is a slow-drying paint made from pigment suspended in oil. Unlike acrylic or watercolor paints that dry quickly and mix with water, oils are hydrophobic, or water repellant. To modify the viscosity of oils (i.e., thin, clean, or otherwise manipulate them), artists use alternative solvents such as medium and turpentine. Varnish is not uniquely used on oils, but it's commonly added over the top of dry, complete paintings for increased gloss and deepened tonal range. More information on using these tools is covered in Exercise 1 (see page 24).

Oils are considered advantageous for their delayed drying time and workability. Other types of paint require you to work quickly to layer and mix colors, but with oil. you have the luxury to wipe away mistaken marks, thoroughly blend shades, and use the same paint for hours. Palettes can be reused for days if you freeze or refrigerate them between use (this slows drying); otherwise, wet paint can sometimes be salvaged from under dried paint skins using a palette knife.

PREPARING PAINT SURFACES

When working with oil paint, be aware that the slow-drying oils can seep into and deteriorate unprepared surfaces. Commercial oil papers are treated with a barrier that allows oil paints to stay on the surface while absorbing water and solvents. If you're not working on oil paper, surfaces need to be prepared by priming, which is coating a surface with water-based paint (gesso or acrylic) to seal and protect it. When priming, apply additional layers of gesso as needed for full coverage, optionally sanding between dried layers to achieve the desired surface texture.

Surface material and texture are a matter of personal preference. Options include bouncy, bumpy stretched canvases; more solid canvas boards and sturdy, flat wood panels; and lightly textured paper. Alternative surfaces include primed cardboard, book covers, and even rocks. Different surfaces have various textures, and priming can be used to further alter that texture. Layering thick gesso builds an interesting face, while thin, smoothly applied gesso forms an even one.

I like working in thin, careful layers, so I generally opt for surfaces that are quick, solid, and smooth: prepping wood boards with two to three layers of acrylic paint and light sanding; prepping paper with one to two priming layers and no sanding; and painting on preprimed canvas board. I've found that the smoothest surfaces are produced by priming and sanding wood panels with fine grit or wet sandpaper.

PAINTING SURFACE OPTIONS

- **STRETCHED CANVAS:** This surface, canvas pulled across stretcher bars, may be the most traditional oil painting surface. The canvas is lightly textured with some give since it's stretched across a back frame.

- **CANVAS BOARD:** This is stretched canvas glued to cardboard backing, and it maintains the light, bumpy texture of canvas without the bounce.

- **MDF (MEDIUM DENSITY FIBERBOARD):** This is an inexpensive board made of compressed and bound wood fiber. MDF can be saw-cut, primed, and used as an uncradled panel that can be framed or propped on a shelf.

- **WOOD PAINTING PANEL:** This cradled wood panel has wooden supports in the back for stability and side-view depth.

- **OIL PAPER:** This is heavyweight paper, treated for protection against oil absorption or degradation. It can be purchased in pads for a fast, accessible painting surface option and for the feel of working on raw paper.

- **STURDY PRIMED PAPER (IDEALLY 90 LB [243 GSM] OR HEAVIER):** I prime paper from my mixed media sketchbook for the convenience of having it on hand. While I use 98 lb [160 gsm] paper,

the heavier the paper, the less likely the paper will warp. Heavier paper is good for durability and quality.

- **ALTERNATIVE SURFACES:** Artists can use cardboard, recycled hardback book covers, rocks, wood planks, terracotta pots, a taped-off square on your jeans, or other upcycled trash-to-treasure items that can be primed. When working with these materials, make sure to lightly sand any glossy, smooth surfaces. Roughing them up helps the primer paint adhere.

NOTE *From top to bottom are a stretched canvas, canvas board, MDF panel, and cradled wood panel.*

BASIC OIL PAINTING SUPPLIES

- **PAINT:** Oils can be purchased in student and artist or professional grade. Artist grade oils are more expensive because they contain more pigment, offering better opacity and color coverage. Student grade paints generally have less pigment and more oil in composition. (See suggested paint colors, page 19.)

- **PALETTE KNIFE:** I recommend a thin metal knife with good flexibility. This tool is used to scoop, mix, and optionally apply paint.

- **PAINT PALETTE:** Many options exist for paint palettes. I use a glass picture frame over neutral-colored paper. Use something flat that's easy to scrape clean.

- **HAND-HELD RAZOR SCRAPER:** This tool comes in handy for cleaning the palette.

- **MEDIUM:** This is used in place of water to adjust the viscosity of paint (see page 22). Three mediums to be aware of are turpentine, Liquin (made by Winsor & Newton), and linseed oil. Turpentine is clear, liquid paint solvent that speeds drying when added to paint. Liquin is gel-like and maintains the body of the paint while also speeding drying. Linseed oil adds more oil to the paint, diluting pigment concentration and slowing down drying time. A thin layer of oil paint mixed with turpentine or Liquin might dry overnight or in a few hours, while adding linseed oil keeps paint wet over the same amount of time. I use Liquin as my primary medium and a type of turpentine called odorless mineral spirits for thinning paint and cleaning brushes. I don't use linseed oil.

- **PAINTING SURFACES** (see page 13)

- **RAG**

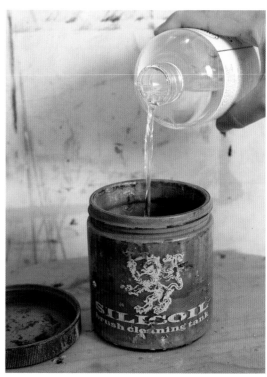

- **BRUSHES:** I have a variety of brushes: round, flat, angled, filbert, short-handled, long-handled, and brushes for oils and acrylics. Oil brushes have thicker bristles than acrylic brushes (that feature makes it easier to move heavier-bodied paint), but I love using cheap, variety pack acrylic brushes. Because I enjoy working in very thin, smooth paint layers, I appreciate the soft bristles and seamless blending power of acrylic bristle hair. I've ruined many brushes over the years, scrubbing oil paint out of the bristles while painting session after session. Starting with a cheap variety pack allows you to experiment and get a feel for different brush head shapes. I recommend starting with some small round brushes for detail work, midsized flats for covering larger areas, and small to medium angled brushes for creating clean edges and lines.

- **TURPENTINE (OR PAINT THINNER):** Turpentine is a solvent useful for cleaning brushes and thinning oil paint. Mixed into paint, it dilutes pigment and speeds drying time. As a medium, this is great for building thin initial painting layers. You can also use it to clean brushes. There are different types of turpentine you can use. I recommend odorless mineral spirits, produced to decrease chemical odor.

- **SILICOIL BRUSH-CLEANING TANK:** This is a small plastic tank with a lid and metal coil inside that is filled with paint thinner. (I fill mine with odorless mineral spirits.) Oily brushes can be run through the paint thinner and over the coils to clean bristles after a painting session or between color changes.

- **SOAP:** Standard liquid or bar soap, shampoo, or brush cleaner or oil soap can be used after painting to remove residual paint from bristles. While paint thinner is fast and effective, soap has fewer harsh chemicals and can be used after paint thinner for additional brush care.

- **GLOSS VARNISH (OPTIONAL):** This varnish layers over fully dry, finished paintings for an even, glossy surface and can enhance the look of saturation and contrast in a piece. It's available in spray or brush-on liquid.

ADDITIONAL SUPPLIES FOR TRANSFER DRAWINGS

(See Exercise 2: Transfer drawing on page 38.)

- **ARTIST OR MASKING TAPE**

- **PENCIL** (any kind)

- **BLACK CHARCOAL STICK OR HARD CHALK PASTEL:** I frequently use colored Prismacolor

NuPastel Color Sticks in my transfer drawings to have more control over the color of the line work and how it relates to the colors of my painting, though opting to use charcoal alone will work fine.

- **TRACING PAPER:** Transfers can be made by covering the back side of a printed image or by covering the back side of a traced image, depending on your needs.

- **FIXATIVE SPRAY (OR HAIRSPRAY):** This can be used to keep your finished drawing from smearing or wiping away.

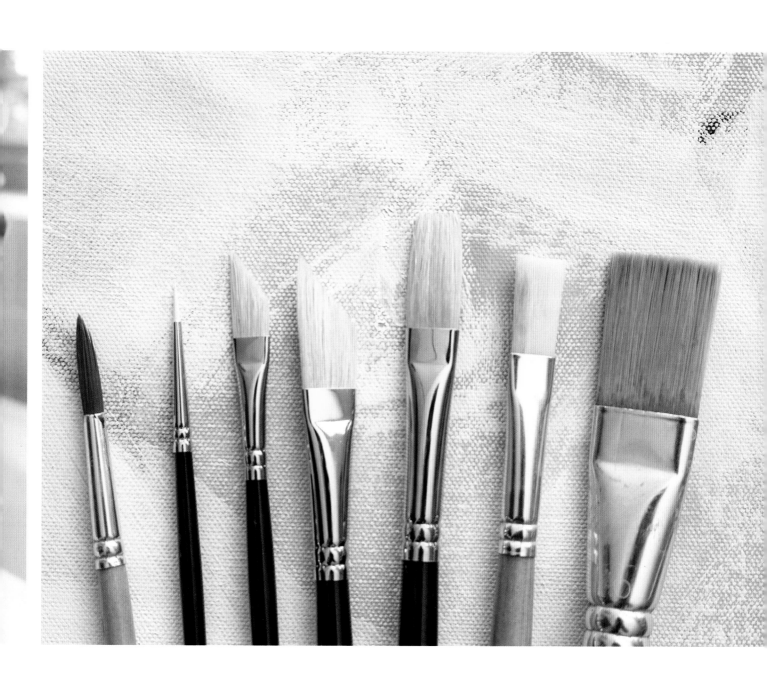

PAINT COLORS

At right are the paint colors I use most frequently. When gathering your own working set of paints, you'll need at least the primary colors (red, yellow, and blue), along with white and black for tinting and shading (lightening or darkening). The list includes additional colors I find useful for general mixing ease and for creating specific vibrant hues. At the end of the list are two very useful browns, which are helpful for skin tones, landscape, still life, and mixing neutral colors. Burnt umber is a darker brown and burnt sienna is a medium, reddish brown. Both are great!

- *Titanium white*
- *Mars black*
- *Dioxazine purple*
- *Quinacridone magenta*
- *Cadmium red*
- *Cadmium orange*
- *Cadmium yellow*
- *Phthalo yellow green*
- *Sap green*
- *Phthalo blue*
- *Ultramarine blue*
- *Burnt umber*
- *Burnt sienna*

To Use Black Paint or Not to Use Black Paint?

As you become familiar with the materials list, you should know that I included a controversial figure: The name is Black—Mars Black. In the painting world, some caution against using this color. I like black paint for its flexibility. It provides unique color options, available no matter what subject matter or style I choose to work in. It's useful as a pure hue or to deepen the shade of mixed colors. While black is arguably useful to create deep tonal contrast in pieces, some think it hinders more than helps, believing that black can flatten an image and that artists stretch more creatively and critically without having black on their palette.

Examining work from artists who explore alternative color choices in their shadows (such as Vincent Van Gogh) strengthens my personal interest in color play.

But I'll never forget the relief I felt the first time I used true black paint to paint the pupil of an eye. Deepened contrast arrived in my paintings before my eyes, and I finally achieved the look I'd been searching for, after years of Payne's Gray being the darkest color on my palette.

Black can be useful for abstraction, realism, and even hyperrealism, craftily weaving artifice into boldly realistic depiction. My advice would be to play, experiment, find things you like, and do what you want. What do you think?

BRUSH CLEANING

As previously mentioned, oils are water repellent. Water alone can't be used to clean them, unlike acrylics or watercolors. Paint thinner, soap, or shampoo are necessary for cleaning brushes used with oil-based paint. My favorite brush cleaning method starts with wiping excess paint onto my rag or apron and then scrubbing the brush across the metal coils of a Silicoil Brush Cleaning Tank. The tank holds odorless mineral spirits, my favored paint thinner, and paint residue settles at the bottom of the container. To treat brushes well, scrub them afterward with an oil soap or any household soap and water to finish cleaning the bristle hair.

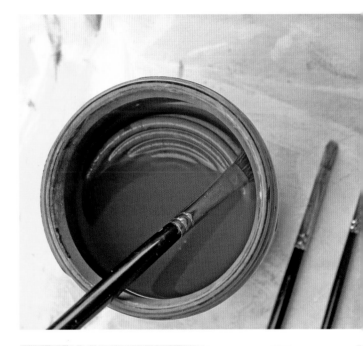

USING MEDIUM

Because oil is hydrophobic, medium is used in place of water to alter the pull and drag of the paint. In addition to adjusting viscosity, medium affects surface finish and drying speed. A number of factors can affect paint texture including age, brand, and grade. Artist grade paints are heavier bodied and have higher pigment levels proportional to the oil content, while student grade paints may be oilier and more translucent. Older paint may dry and thicken over time. Assess the texture of your paint before adding medium to it, deciding how much you want to dilute the pigment or soften the paint flow. As you'll see in the upcoming exercise, medium can be used for general painting as well as for making cool translucent glazes and color effects.

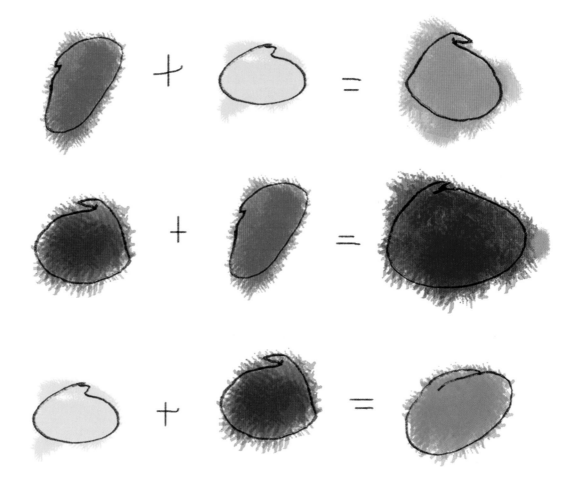

How to Mix Color: A Color Theory Lesson

Understanding how to mix colors correctly increases your power to render visual ideas. We'll review the basics and then do simple color mixing exercises to harness the potential of this power.

The three primary colors—red, yellow, and blue—are so named because they can be mixed together in different combinations to produce most other colors, while no other colors can be mixed to make them. Mixing two primary colors creates secondary colors, which are orange (red and yellow), purple (red and blue), and green (blue and yellow).

Complementary Colors

Colors that sit directly opposite each other on the color wheel are called complementary colors. They can be used strategically in artwork to create bold visual interest and can be mixed together to mute or desaturate hues.

When complementary colors such as yellow and purple are combined, the resulting color is neutral brown. Because of this phenomenon, adding complements comes in handy when you need to mute hues. We'll practice how to do this in the exercise on the next page.

you complement me

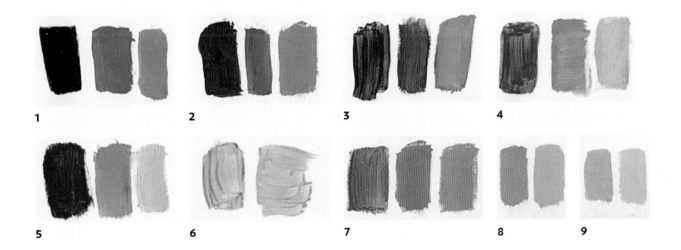

Beyond Primaries

Blue is a primary color, but I included two different blue paints on the supply list because each produces a unique hue. Ultramarine blue produces deeper blue/purple tones, while phthalo blue leans toward electric blue/green hues. Quinacridone magenta is helpful to have on hand when making hot pink or other magenta-based tones. Many people mix red and blue to create purple, but for more luminescent, saturated hues, adding magenta or using dioxazine purple can come in for the win. Here are some hues you can achieve using alternative paint colors. White has been added to colors in varying amounts for tinting.

Swatch Guide

1 Prussian Blue

2 Phthalo blue

3 Ultramarine blue deep

4 Cobalt blue

5 French ultramarine blue

6 Cerulean blue

7 Quinacridone magenta

8 Quinacridone magenta and cadmium red

9 Quinacridone magenta and cadmium yellow

EXERCISE 1: BLENDING COMPLEMENTARY COLORS

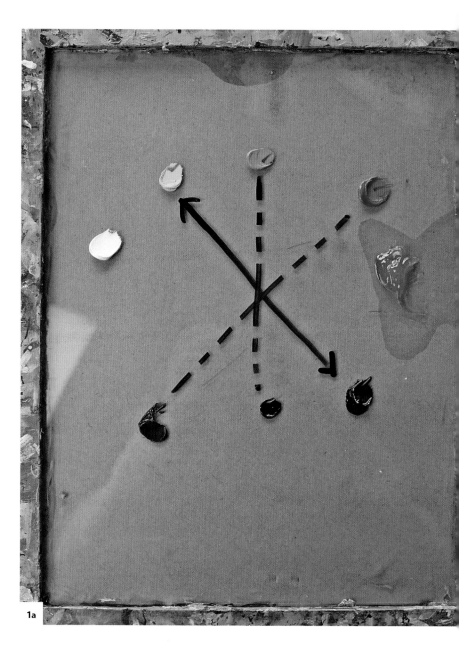

1a

1. Add only small amounts of paint to the palette and brush. Oils stretch further than you may think and can get thick and messy if you aren't careful, so a conservative initial approach is best. Work on primed or oil paper. Brush stacked blocks of yellow, orange, and red paint on the left side of the substrate (your chosen painting surface). Work with a brush conducive to covering the area. I chose a medium-small flat brush.

Experiment with the medium, adding small amounts to the brush to thin the paint as you move across the space, creating a thinned gradient.

2. Starting on the right side of each color, block in each color's complementary hue: purple opposite yellow, blue opposite orange, and green opposite red. Use very small amounts of paint—dark pigment is strong! Experiment with the medium, adding small amounts to the brush to thin the paint as you move across the space toward the center to create a thinning gradient. Clean the brush between color changes to avoid color contamination.

3. Blend the color gradients together at their centers, adding additional pigment if needed, to reveal how the complements mix to create similar mid-tone browns. Practice using medium and paint thinner to aid in creating clean color transitions. By adding medium or turpentine to paints, you can thin them, making them easier to combine in the center.

NOTE *The white paint shown on the palette won't be used yet, but will be used on the next page for Exercise 2.*

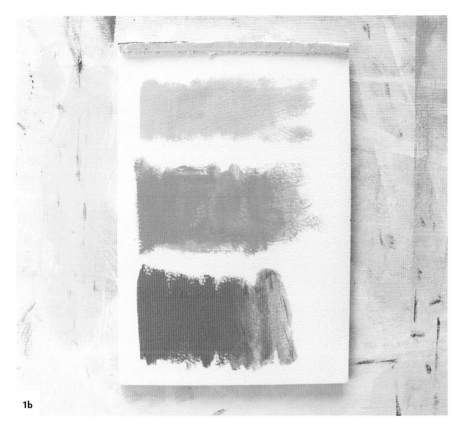

1b

TIP *Wipe off excess paint from the brush when needed to keep your work and space clean. If you start with yellow and move to red, you don't have to clean the brush between colors, beyond wiping off excess paint. Use paint thinner and a rag if you need a quick brush clean.*

3

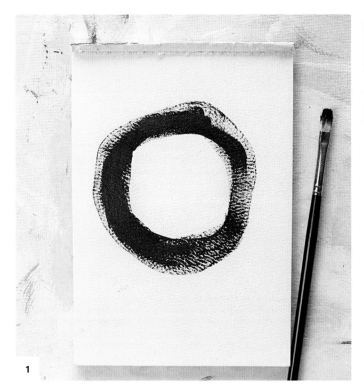

EXERCISE 2: TINTING AND SHADING

Another way to mute and adjust colors is through the process of tinting and shading. Tinting is lightening a color by adding white, and shading is darkening a color by adding black.

1. Add white and black paint to your palette. Paint a white circle on a piece of primed or oil paper. Using a clean, flat or filbert brush, create a black circle around it.

2. Explore using medium and different brush types and sizes while blending the white and black circles. Do you want a smooth transition or one with visible brush marks?

3. Add color, practicing using the paint however you desire. (The swatches show the colors I added.)

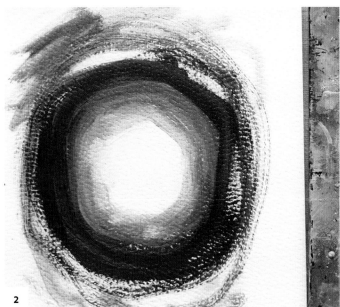

4. Here's what my palette looked like when I was finished. How is yours looking? Remember you can use a razor scraper to remove dried paint or clean your pallet.

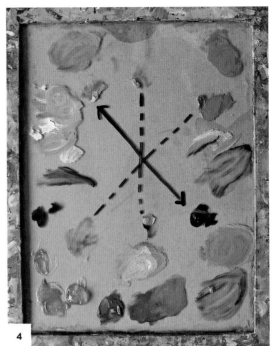

4

TIP *When using white or black to adjust the lightness or darkness of a color, remember these two tips:*

- *Don't destroy the hue of your paint by adding both black and white to it, turning it more of a gray color.*

- *Black isn't the only color that can be used to darken hues. Experiment with other dark colors.*

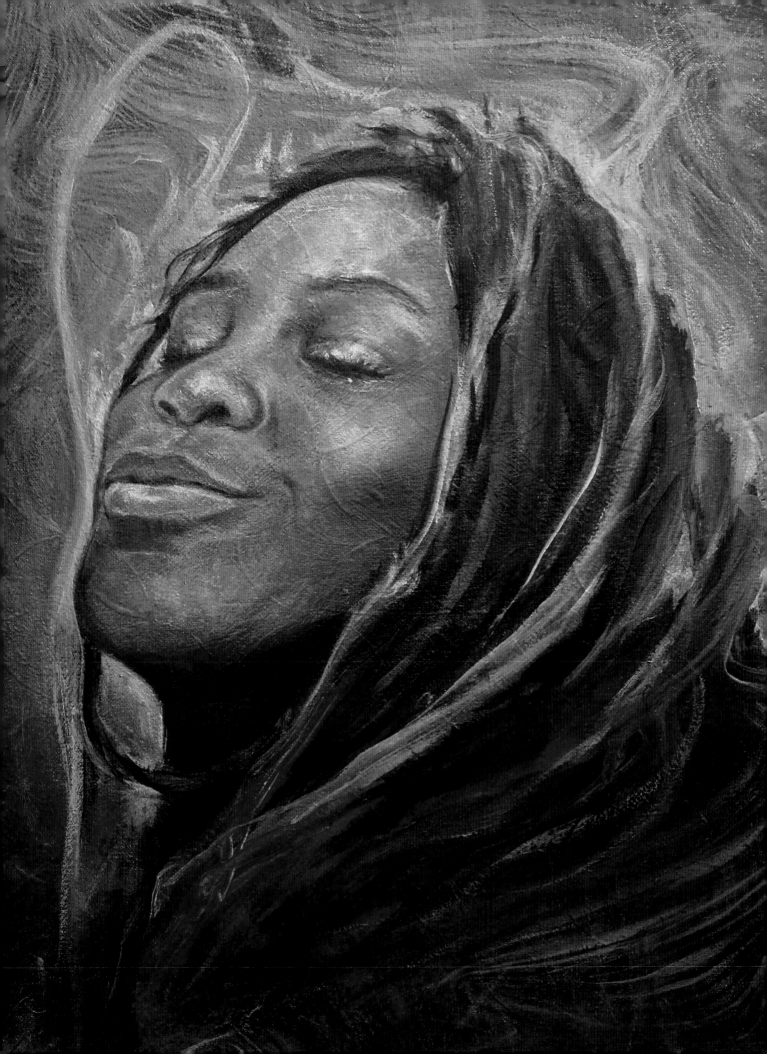

TECHNIQUE GLOSSARY

*This chapter contains a technique overview and
helpful exercises to get you started.*

Do you love the adventure of new experiences but struggle with intimidation and feeling overwhelmed? My pal, this chapter is for you!

I'll break down techniques, tools, and helpful exercises to orient you through the learning process. Once you connect and familiarize yourself with the basic concepts, you'll be able to remix and expand them in your own work. Through small and simple tools, master painters built this craft. Remember that you're part of a generation of artists expanding the field in new ways. The evolution of art has been an awfully big adventure, spanning from cave drawings to *The Mona Lisa* to the many wonderful artists of our generation to us—and what the future of art still holds.

With my supportive coaching, this glossary, an exercise on brushstroke techniques, and a glossary-term review, you'll be mastering foundational oil tools in no time.

TECHNIQUE GLOSSARY

- **ALLA PRIMA:** This is a painting technique also called *wet on wet*. In this method, paint is layered without drying between additional layers. This is a comparatively quick approach to alternative techniques that require partial to full drying between layers. (See Exercise 1: Basic painting techniques on page 32.)

- **BLENDING:** This term refers to smooth paint transitions that are made when paint is wet for soft color effects and shading shifts. (See Exercise 1: Basic painting techniques on page 32.)

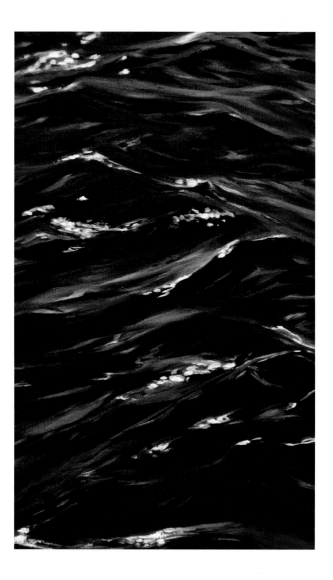

- **GLAZING:** Applying a thin, translucent layer of paint over a painting. Glazing over dry layers allows colors to optically blend without the layered pigments mixing. Glazes can be used to adjust hues, shadows, and cast light, as well as build up visual interest. (See Exercise 1: Basic painting techniques on page 32.)

- **SCUMBLING:** This is a dry-brush technique that uses little or no medium to roughly apply thin paint to a painting surface, creating a light, textured color effect. Rather than produce a smooth glaze, this leaves some of the underpainting exposed for a broken paint application. Scumbling can be used to create atmospheric haze in scenic paintings. (See Exercise 1: Basic painting techniques on page 32.)

- **IMPASTO:** Applying paint thickly to create visible brushwork or surface textures, this method can be used to add visual depth, shadow, dimension, foreground texture, or guiding lines and focal points to a painting. (See Exercise 1: Basic painting techniques on page 32.)

- **VARNISHING:** This is applying a spray or brush-on varnish to a painting after it's dry to unify the surface sheen or add a glossy finish and color depth. (See Exercise 1: Basic painting techniques on page 32.)

- **CHARCOAL TRANSFER DRAWING:** Transfer drawings can be used to trace photographs or transfer previously made drawings to a substrate before painting. To do this, cover the back of an image with charcoal or chalk pastel, tape it face up on the substrate, and trace over the image to transfer the drawing onto the surface. (See Exercise 2: Transfer drawing on page 38.)

- **BLOCKING IN:** This is painting the general colors and shapes of a painting to cover the surface quickly, establishing harmonious composition and color. (See Exercise 3: Blocking in an underpainting on page 42.)

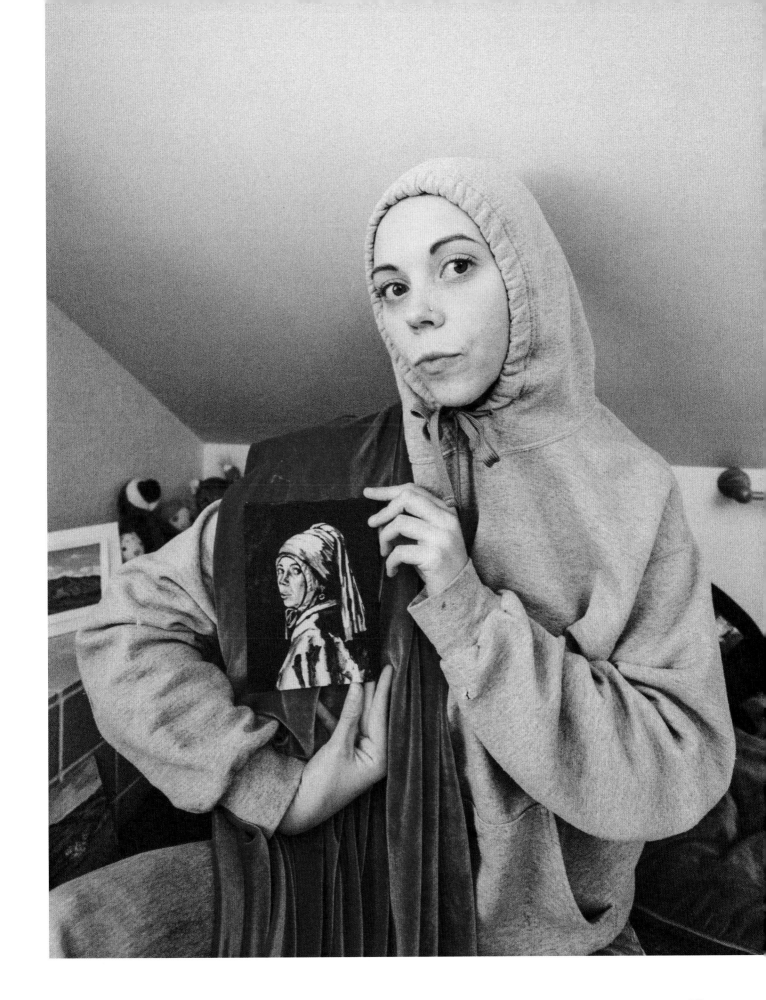

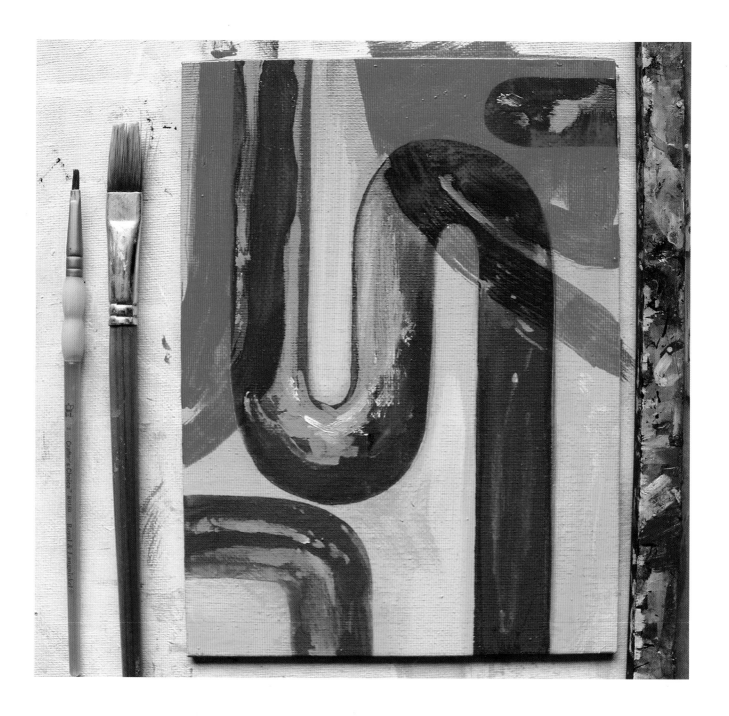

EXERCISE 1: BASIC PAINTING TECHNIQUES

In this exercise, you'll combine painting and brushstroke techniques to form an abstract, expressive painting.

For this project, I worked on a primed canvas board.

Techniques covered in this exercise are as follows:

- Blending
- Alla prima
- Glazing
- Scumbling
- Impasto
- Varnishing

NOTE *You can choose your own color palette for this exercise. Before starting, I found a predetermined set of colors to reference as a guide. Follow my color choices to learn how I mix each color or choose your own palette for an added challenge and opportunity to personalize the exercise.*

A Layered Approach

A technique often encouraged in oils is called painting *fat over lean*, meaning that initial layers should be thin, building up to thicker layers. This is a more stable, easy way to layer paint that allows initial layers to dry relatively quickly. A good way to keep early paint layers lean is through carefully adding turpentine or a medium such as Liquin that quickens drying time.

Since you're painting alla prima (a wet on wet technique, see page 30) in the first part of this exercise, a relatively thin first layer in step 1 means avoiding working over a thick, wet base later. To apply paint thinly and smoothly, experiment with adding small amounts of medium to your brush and/or paint. I use Liquin to swirl and stretch my pigment, keeping my paint to medium proportions balanced enough for good brush pull and building an opaque, pigmented layer. For retaining opacity, you'll want a higher balance of paint to medium in your mixture. When you choose to thin paint using a paint–thinning solvent, such as odorless mineral spirits, be aware that it behaves differently from oil-based mediums, chemically reducing the paint oil to increase drying speed. It works well, but should be used with care.

1

1. Mix white and burnt umber to create a light-peach color. Cover your surface (I used a preprimed canvas board) with a relatively thin, opaque layer of peach, brushing on additional paint as needed in smooth, directionally consistent motions. I used a midsize, flat brush for this, opting for something that fit the size of the canvas board and provided smooth, easy coverage.

2. Blending: Create a background color gradient. Mix white and yellow paint to create a light yellow and beginning at the bottom of the

2

TIP *When smoothing gradients, I like to use a clean, dry, fine-bristled brush and use light sweeping motions to create an even flow of color gradation.*

painting, brush the paint onto the surface with long back-and-forth motions to create smooth color transitions. Concentrate the majority of the light-yellow paint at the bottom of the surface and allow it to thin and blend as you move upward.

3. Accentuate the background color shift by adding thin burnt umber paint to the top of the painting and blending it downward. If desired, use some white paint in the middle

portion of the canvas to help with blending and to preserve the light background peach color between the burnt umber top and yellow base.

4. Alla prima: Add a few bold shapes. After mixing a small amount of white with ultramarine blue for a medium blue object color, I experimented with two methods for object layering:

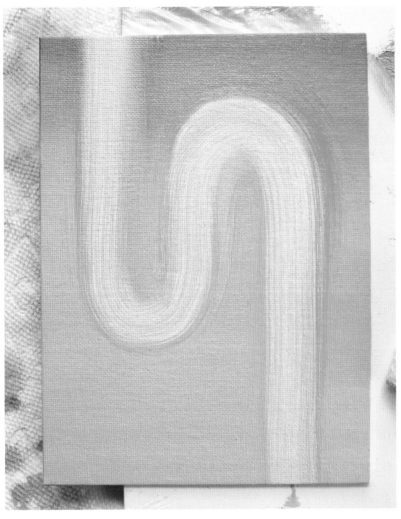

- **METHOD 1:** *Wipe away a silly, curving central line using a paper towel and a paint-thinner dampened brush for edge work if needed. Carefully fill the negative space with medium blue.*

- **METHOD 2:** *Work 'wet on wet'. Add two blue corner shapes without wiping out any paint first. Paint directly on top of the tacky base layer.*

 NOTE *If you tried each method, how did it feel painting on a wiped surface versus over wet paint? Did you like one method better than the other? Can you see a difference in effects?*

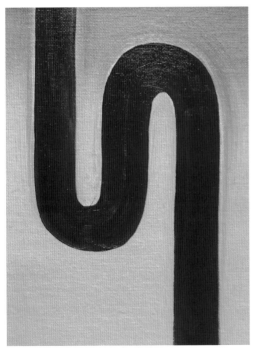

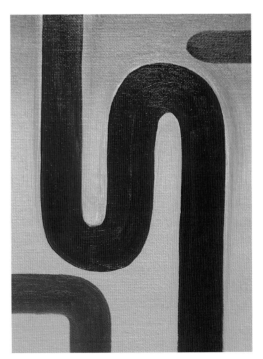

METHOD 1

METHOD 2

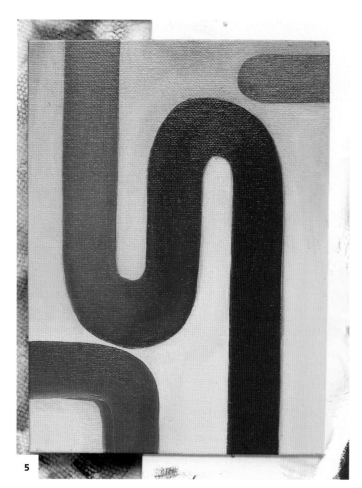

5

6

8

TIP *Climate and paint viscosity can affect the dry time of a painting; working with thin paint in a warm attic, my painting took about two days to dry before it was ready to varnish.*

5. Layer more paint from the palette onto the image to build opacity in the forms and background. In this step, I also created a fun color gradient in the central shape, adding yellow to medium blue for an aqua color transition that begins at the top of the composition and fades into blue. Add refining color contrast and opacity to the edges between your objects and background color using long, smooth brush drags. Allow the paint to dry until it's no longer tacky to the touch before moving onto glazing.

6. Glazing: Create a bright red, semitransparent glaze by mixing medium and cadmium red paint. Create a mixture that's bold as well

as translucent—not too opaque and not too transparent. The glaze casts a color over the dry painting without fully covering up the bottom layers. With the first glaze still wet, add a second glaze of mixed cadmium yellow and Liquin selectively to the lower half of the painting.

7. Scumbling: In this step and the next one, consider how you apply paint. Do you want an even application, or would you like to try scumbling? Notice areas of broken paint in my sample where previous layers are left exposed. This is a good time to experiment with the properties of transparency versus opacity in oil painting.

9

8. Impasto: Mix white and phthalo blue for fun detailing and a glowing color effect. Apply this mixture thicker than in previous layers, using loose, blocky brushstrokes or dabbing and spreading movements of the palette knife to apply paint and create texture. I played with adding electric blue to the central shape and in between broken parts of the glazes, after my niece suggested I make the shapes look like neon lighting. The light blue was made by mixing phthalo blue and white to create a bright hue that contrasts with the darker blue beneath it. Touches of white added for highlight further emphasize the illusion of glowing neon color.

9. Varnishing: As an option, varnish the painting when it's fully dry to the touch. Notice the difference in surface sheen on the unvarnished painting. Glazed areas of the painting are glossier than other areas. When using oil paint, it's common for layers to dry with varying sheens. Adding varnish over a dried work creates an even, glossy topcoat. If desired, experiment to see how varnish affects the surface sheen and color depth of your final painting.

EXERCISE 2:
TRANSFER DRAWING

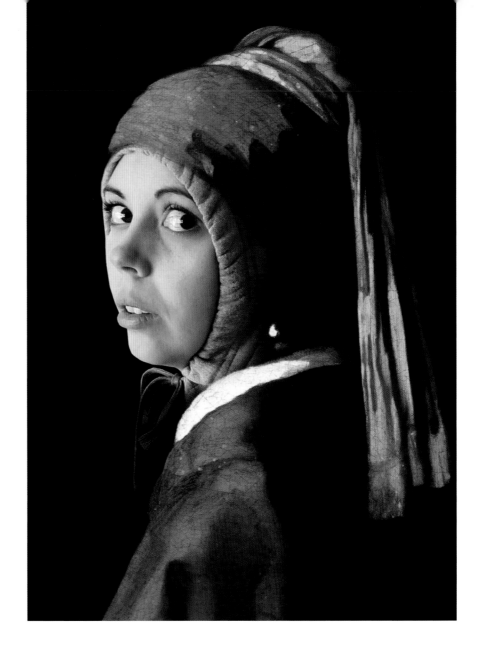

You'll use a basic sight drawing technique for some lessons in this book and transfer drawing for others. This exercise will show you how to do a transfer drawing, to introduce one useful technique for painting preparation. As you familiarize with oils, how you approach drawing and painting is up to you.

While traditional drawing techniques aid confidence and conceptual skill building, transfer drawing has come to serve me in unexpected ways. In the short term, it's given me early access to structurally accurate drawings and a shortcut to painting preparation. In the long term, tracing subjects has helped me learn things such as noticing important features in an image; lines and angles that help form perspective; and how to use shorthand, simplified shapes when constructing an image.

1. Select a drawing or printed photo you'd like to transfer to a new surface. Images should be on paper that your charcoal or hard chalk pastel can adhere to, such as printer paper. The images can be color or black and white, as long as you can see image details and values well enough to trace them.

2. Coat the back of the image in either charcoal or chalk pastel, using a color that will contrast with your transfer surface. Cover the entire back side of the image or cover selected areas as needed. Shake any residual charcoal powder or pastel chalk into the trash.

2

3. Tape the image with the charcoal or pastel side against your desired surface using two to three pieces of tape. Make sure you can raise a corner of the paper to check the transfer as you work, but don't allow it to become detached or misaligned during the transfer process.

TIP *As you're learning this method, don't feel discouraged if you need to troubleshoot parts of the process to feel more confident in your transfer skills. The technique is fairly simple, but all things improve with practice.*

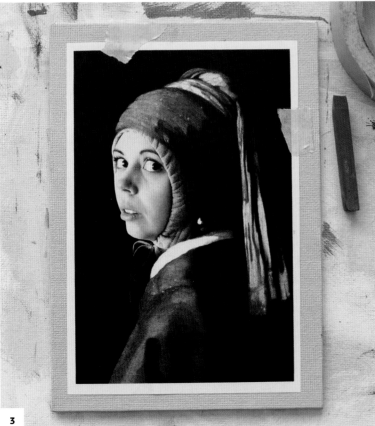

3

4a

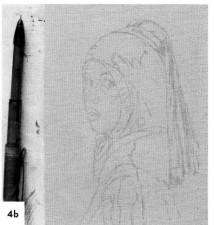

4b

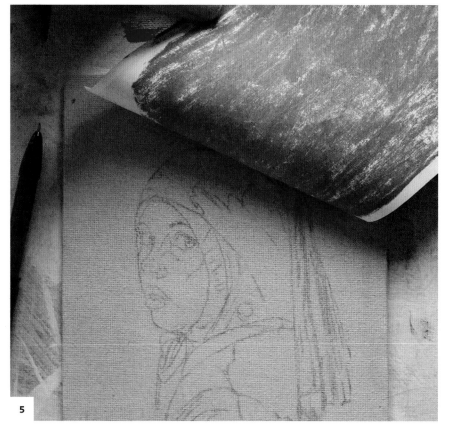

5

Why Use Transfer Drawings?

While studying artist Jenny Morgan's approach to contemporary portrait painting and hyperrealism, I found studio images of her process using transfer drawing to prepare large canvases for figurative painting. I quickly followed suit in my own portrait work and discovered that in painting, much of the labor of creating realism happens beyond the initial drawing stage. Portrait painting can feel like sculpting in paint, defining bone structure via shadow, light, and color placement. By using transfer drawing, I felt able to move some of my focus from foundational drawing efforts to exploring hyperrealism, paint, and color.

4. Using a pencil, outline all relevant shapes and objects in the composition when tracing the image. Carefully indicate other significant areas of color or shadow transition, marking it with a guiding line. Study the image to see which areas I've traced, such as facial features and shadows.

5. Check your work. When satisfied, remove the taped image. Blow or lightly brush away any unwanted residue, if necessary, but take care to not lose or lighten the transfer too much in the process.

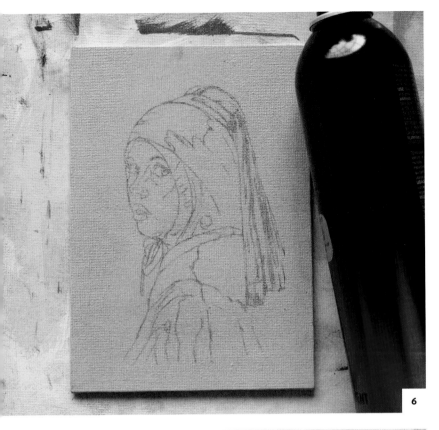

6

6. Spray the image with fixative or hairspray to secure the drawing to the surface so it won't come off. Note that fixatives saturate powder and chalk and that will affect the color. In this case, it made the drawing stand out more against the lighter background.

7. Filling in the image is an option. I painted one layer of black acrylic paint on the canvas. I frequently begin paintings and background layers in acrylic before moving to oil paint because acrylics dry so quickly. Their fast dry time makes them suitable for coloring or toning a canvas before painting, blocking in an image, or quickly building up opaque initial layers. After a rough round of acrylic layering, I can use oils for a more highly rendered, blended, creamy image. You can always paint wet on wet with oils, but sometimes it's easier to work on top of a dry layer, and acrylic paint produces a fast, dry base. I'll have fun finishing this painting, which is inspired by the Baroque-period portraiture style in which Johannes Vermeer painted his *Girl with a Pearl Earring.*

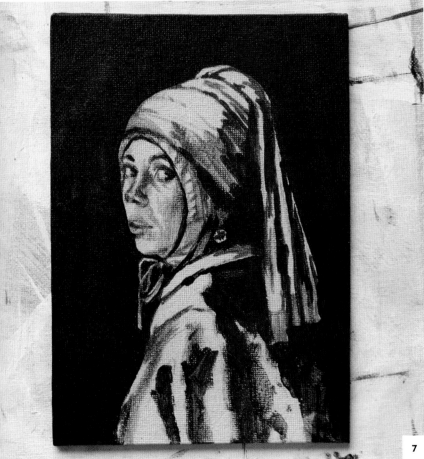

7

EXERCISE 3: BLOCKING IN AN UNDERPAINTING

In this exercise, you'll use basic sight-drawing technique and complete the beginning stage of preparing a painting by blocking in the image. Blocking in is a quick method of underpainting that establishes the general composition of a painting through applying simple blocks of color. This creates a harmonious foundation for adding and refining subsequent layers of detail, contrast, and color.

1. Tape off a 4″ × 6″ (10 × 15 cm) rectangle on a substrate to create borders; I worked on mixed-media paper. To prep the paper for painting, coat it with one to two layers of white gesso or acrylic paint. Cover the surface fully using a brush (such as a medium-width flat brush) appropriately sized for fast, easy coverage and allow the gesso or paint to dry between layers. This step of priming the paper seals the surface to keep oils from leeching into it and causing deterioration. If you're working on oil paper, you don't need to prepare the surface.

2. Working from the reference photo, loosely sketch the image. (I used a mechanical pencil.) As you sketch, think about establishing significant lines in the composition as they relate to the height and width of the paper. How far up from the bottom is your horizon line? Where does the base of the cloud start along the edge of the paper? Hold up your pencil against your reference and measure subject angles and lengths. Account for the flatness of the mountain on the horizon, the slight upward diagonal projection of the clouds, and silhouetted tree tops framing the lower corners of the image. Ensure the composition is proportional with well placed, key lines; keeping in mind the larger picture. Details are less important.

3. Layer colors to create the muted blue mountain range. Use white, phthalo blue, ultramarine blue, and quinacridone magenta to create a small range of blue and lilac hues. Remember that magenta and blue mix to create purple. You can shift the color to appear more pink or more blue depending on how you mix. White can be added to lighten the hues.

Softly brush the colors onto the page in simple shapes, adding small amounts of Liquin to the paint to thin it if necessary. (Thinning the paint can be beneficial in instances where the paint texture feels heavy or sticky and you want to work with a lighter amount of paint.)

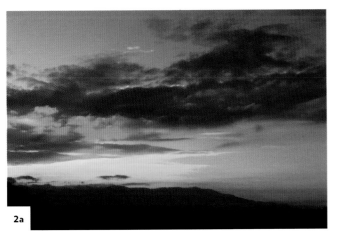

2a

2b

3a

3b

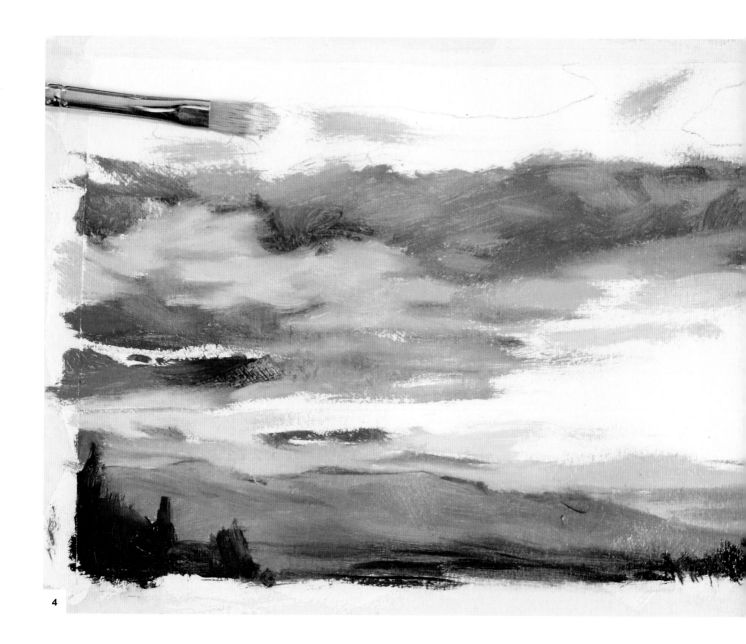

4

4. Establish the dark tree silhouettes in the foreground using ultramarine blue mixed with small amounts of magenta and orange to adjust the hue toward the dark, neutral blue you see in the image. Use a small brush and small brushstrokes to create suggestive detail when shaping the silhouettes of the triangular pine treetops.

5. Expand your color palette and create warm hues. Use white, cadmium yellow, and magenta to mix light, rosy peach and yellow colors for the horizon above the mountain range. Continue working up the composition, blocking warm tones into the clouds.

Use blue and purple paint from the mountain range to create the shadowed cloud tops. Because blue and orange are complementary colors (see page 23), magenta will be a helpful friend to minimize muddiness and ease transitions between the warm, light areas and the cool, shaded ones.

6. Use a mixture of white and phthalo blue to create a light blue and block in the sky. Fully cover the white areas of the primed paper.

7. Make any color or contrast adjustments that feel appropriate to finish establishing the image. This is an

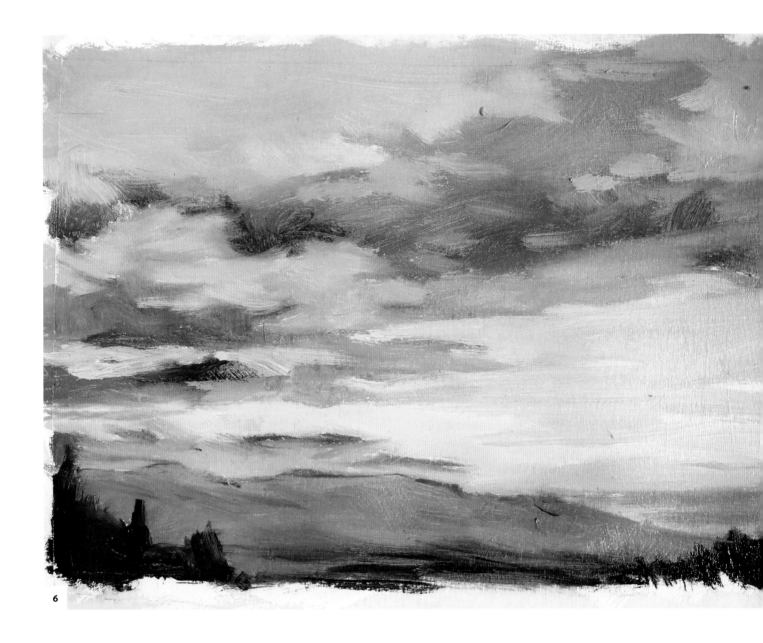

6

underpainting exercise, so don't over-think it. Take a final look over your painting and feel good about it.

8. At this point, you can explore on your own and continue developing the exercise into a finished painting or remove the tape and call it good—but be mindful of still-wet paint. If you're struggling with removing the tape, a hair dryer can help loosen the adhesive.

TIP *After I remove tape from a piece I'm working on, I like to give it a final look over. Then I decide whether to do more work, increasing contrast or detail, or call it finished. To increase contrast, I punch up my darks, lights, and hue saturation by adding color or glazes over the top of the painting. (See Exercise 1: Basic Painting Techniques on page 32.) Things like finishing details and clean edges can make a big difference in overall piece quality, so it's often worth taking another look.*

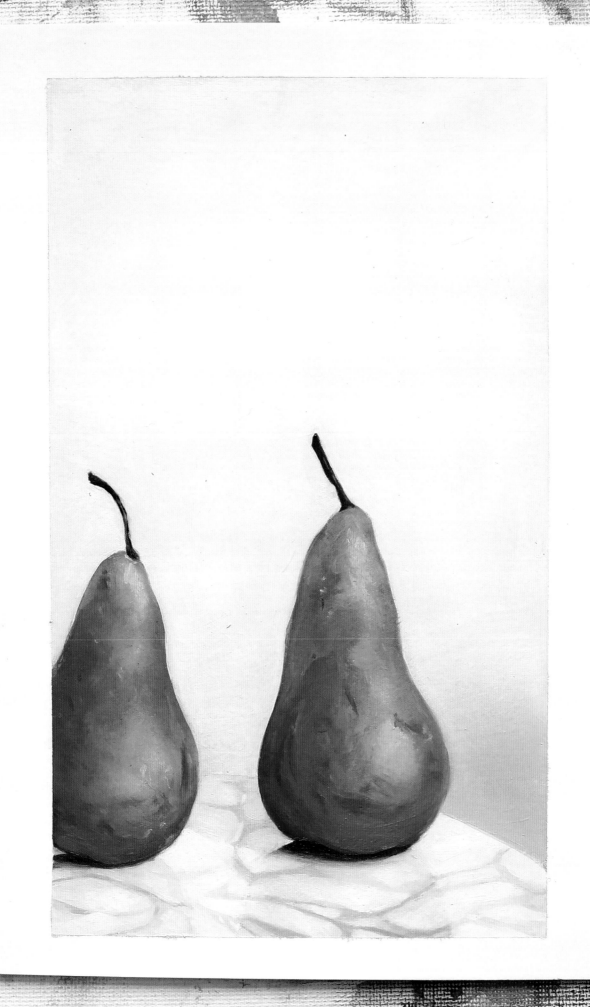

SEE LIKE AN ARTIST

*In this chapter, you'll engage in skill-building projects
to learn critical observation and image construction.*

Now that we've covered the basics of oil painting materials, color mixing,
and technique, let's discuss using a critical artist's eye.

This is a technique that you can experiment with in your daily life. To see
like an artist, you must train your eye to see more than you normally take
in: studying color in things around you, noticing shapes of tree silhouettes,
discovering how light and shadow affect the colors you see, and considering
what colors you'd mix to paint the color of a wall.

Learning to see like an artist is learning to notice more detail and color in
the world around you and returning curiosity to your vision.

In this chapter, you'll use simple project concepts—still life and flower paintings—to deepen your understanding of how seeing like an artist can be used practically in your work. By breaking subjects into steps, I'll guide you through useful ways to observe and construct the images you hope to build now and in future work.

Adopting this practice can serve you in many ways. I recall attending a creative conference where Vince Kadlubek, cofounder of the arts collective Meow Wolf, spoke. He talked about the group's experiential project, *The House of Eternal Return*, which featured a home that appeared typical, but had entrances to a mind-bending installation experience through one of two portals: a washing machine and a refrigerator. Kadlubek talked about his artistic desire to return wonder to people's vision. He hoped that if he could turn a refrigerator into a magical portal, perhaps he could help return magic and curiosity to the way people look at other common things in life, such as a tree.

Here is a suggested to-do list for developing your artistic eye:

- Hold very still and watch the movement of the outer edge of a cloud.

- Look closely at light glistening on black hair or across skin.

- Search for the color green in a sunset. (Hint: Sometimes you can find it between orange and blue.)

lesson 1:

STILL LIFE

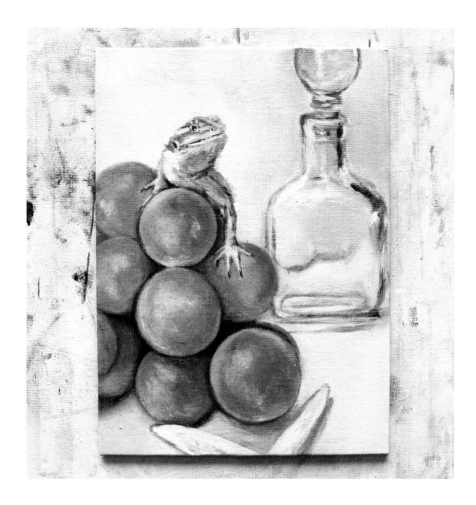

Rendering a still life is a foundational step taken by many new painters. Regularly assigned in painting and drawing classes of all academic levels, the still life asks artists to focus efforts on skill development while using basic observation to technically render light, color, and form. With this project, you'll paint a still life using critical observation to guide your rendering.

Follow my photo (see page 123) and steps for inspiration or create your own assembled still life to work from. This composition was made with assistance from two nieces and a bearded dragon named Blueberry. The painting features the unique challenge of having a very limited tonal range. As you work through the image, playfully consider how to create color intrigue in a nearly mono-chromatic image, finding small opportunities to accentuate the interesting tones in reflective light and stylized realism. If you set up your own still life, will you make a more color-robust composi-tion or do you prefer the palette simplicity of this image?

1. Sketch or transfer draw your still life composition onto a painting surface of your choice. I used a 6″ × 8″ (15 × 20.5 cm) preprimed canvas board and a dark brown Prismacolor NuPastel Color Stick for the transfer drawing.

2. For the transfer drawing, remember to tape down two edges of the transfer image and check that your work has properly transferred to the substrate. (For more information on sight drawing, see pages 43 and 90; and lesson four's drawing samples and exercise found starting on page 69.)

3. Remove any loose pastel powder and spray the drawing with fixative or hairspray. Allow the canvas to thoroughly dry.

4. Make a light glaze using medium mixed with burnt sienna. The glaze should be thin and translucent enough to see the underlying drawing through it.

5. Mix burnt umber, burnt sienna, and phthalo blue on a palette to develop the shaded areas of your image. When mixing colors, adding more blue paint will produce darker, green-tinted shadows. Adding medium to your paintbrush thins colors and allows you to work more delicately while building layers of shadow and highlight in areas such as the glass bottle.

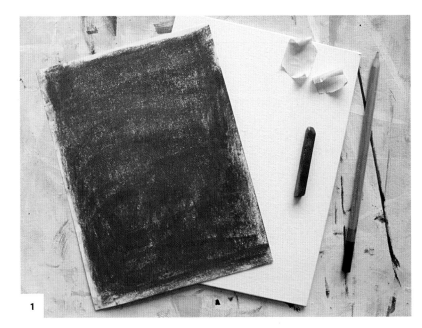

1

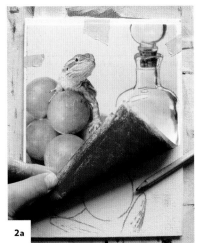

2a

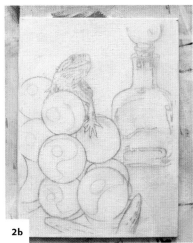

2b

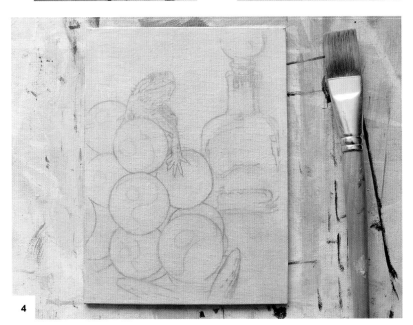

4

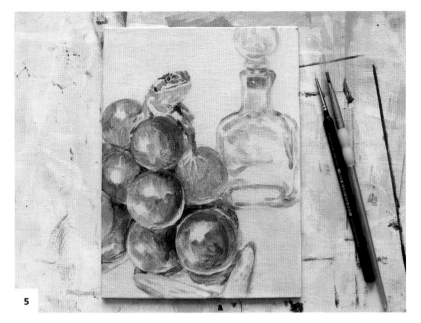

5

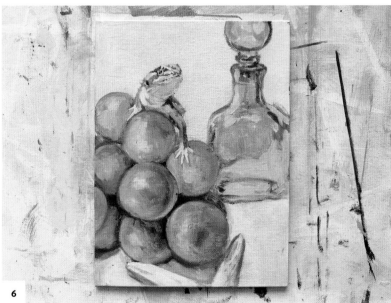

6

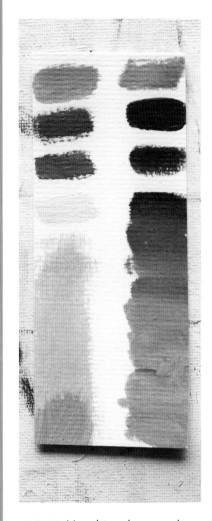

NOTE *Use this color swatch as a guide to create colors for your painting.*

As you work, pay attention to the way light affects the objects. The spherical grapes have dark shades where they curve away from the viewer as well as highlighted areas.

6. Add small amounts of white to the mixture of burnt sienna, burnt umber, and phthalo blue to create a range of mid-tones and lighter tinted areas. As you mix the tones, reference the swatch guide to see the range of colors that can be created using different blends of these four paints. I used these colors to complete both this step and the next, filling in the canvas board with shadows, mid-tones, and highlights. When it comes to using pure white paint, save your tonal best for last. (This advice is from contemporary painter Andrew Tischler, who encourages artists to think tactfully of where and when to use bright pigment.) While you'll use a lot of white in this image, pure white paint will be most useful in creating final highlights when there is a range of interesting tonal variety behind them.

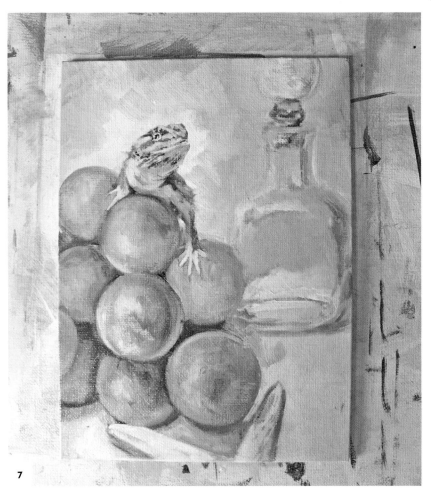

7

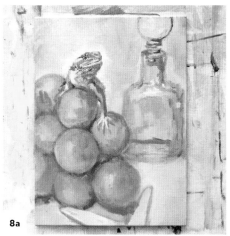

8a

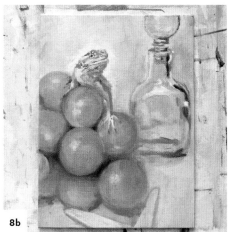

8b

7. Continue layering the image using the mixtures of white, burnt umber, burnt sienna, and phthalo blue. In warmer toned areas of the grapes and the background, use more burnt sienna, and in the deeper, cooler shadows, blue and burnt umber will be helpful.

8. Refine and develop your paint layers, keeping in mind the three-dimensional forms you are sculpting with paint. White can be used to carve negative space around Blueberry and to develop neutral mid-tones on the stone grapes. Build sturdy definition, structure, and opacity in these paint layers.

Additionally, thin lines of deep-blue detailing will help define structure in areas such as the glass in the background and Blueberry's facial features. For this you'll need to use a very fine round tip brush and a careful hand.

9. After allowing the piece to dry overnight, I returned to add transparent colored glazes to selectively improve the saturation and contrast with the warmer burnt sienna-based tones. I also finished defining the lower grapes in the composition. I patiently carved the spherical bulbs, looking at the canvas from a distance to check my work, adjust it, and get the shapes right. Take your time to develop structure.

10. Finalizing work focuses on amplifying color, shade range, and form definition. Reference the color palette I used to finish this image. Shadows are made with burnt umber; dark emerald-colored reflections (mixed with sap green and ultramarine blue paint) define the bottle; and pastel beige-pink and purple freckle the painting to indicate reflective light and add artistic flair. Create these pastels by mixing white, purple, and magenta paints. Paying attention to detail and color play help bring the still life to life.

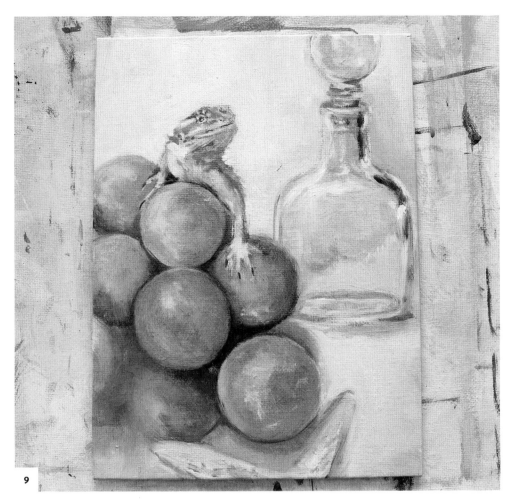

9

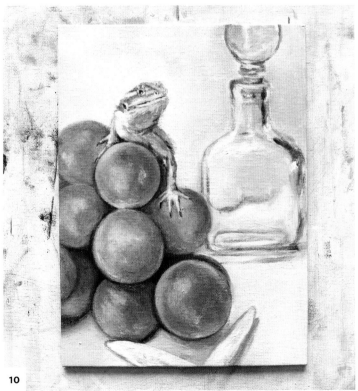

10

lesson 2:
TULIP
PAINTING

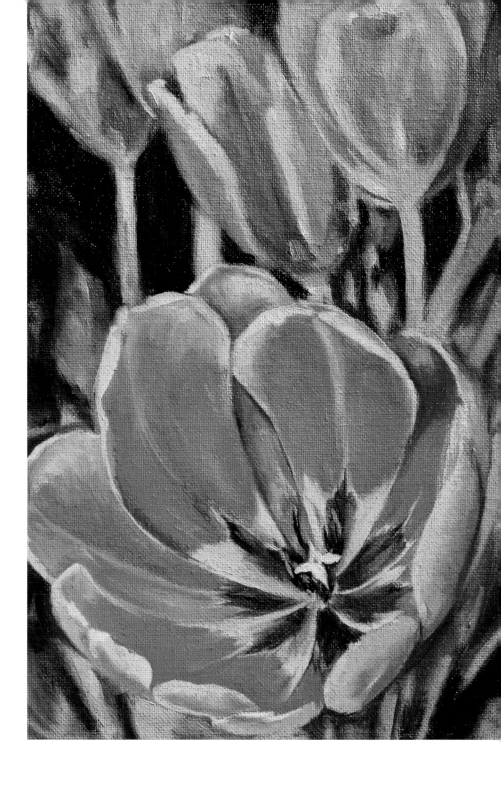

In this project you'll dive into rendering a strong visual subject with bold color choices (see the reference image on page 123). We'll begin by toning the canvas with warm paint, then create a transfer drawing, use color matching to fill in the image, and create shading and highlights to add depth and realism, making the flower pop off the canvas.

1. Prepare the surface. For this project I worked on an 8″ × 10″ (20.5 × 25.5 cm) canvas board. Since the canvas was preprimed, I only had to choose a color to tone it. Canvas toning is a painting technique used historically for a variety of purposes. You'll use it for this lesson to establish the initial color coverage and create a consistent underlying hue. This toning will come in handy later when working on more loosely painted areas of your piece where background color can pop through.

Use a thin coating of rusted orange paint to tone the canvas. Create the shade using a combination of cadmium red and burnt umber. Wet the medium-size brush with clean, odorless mineral spirits (or your preferred turpentine), making sure the brush is wide enough to easily apply the base layer. Use the solvent present in the bristles to mix into and thin the paint. Thoughtfully thinning and diluting the pigment in this step will speed drying time, which may take several hours. Check the surface with light touch to make sure no pigment comes off on your finger before beginning the transfer drawing.

2. I created a transfer drawing using the reference photo (see page 123), choosing from a black charcoal stick or a Prismacolor NuPastel Color Stick in a color that stands out against the orange background. When tracing I like to outline significant shapes and define important color or shadow shifts to help guide my painting later. Reference my traced image for help identifying distinctive features to include in your own drawing. (For more information on creating a transfer drawing, see page 38.)

1

2a

2b

> **TIP** *The amount of time it takes for paint to dry depends on the viscosity of the paint and environmental factors such as heat and humidity. Warm sunlight or a hair dryer can be used to speed the process if desired.*

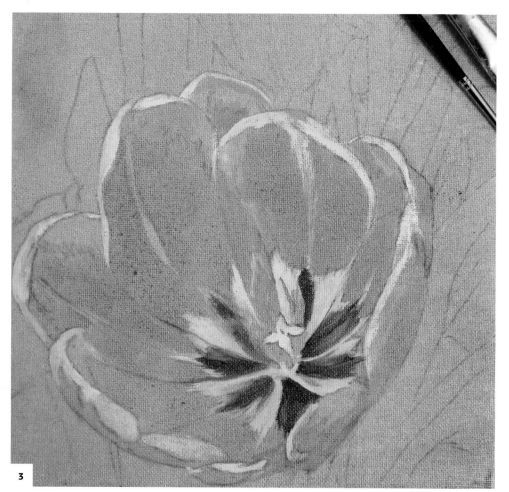

3

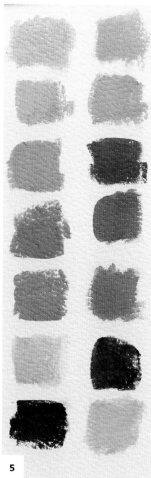

5

3. Define the largest flower head by deepening the red of the petals using the remainder of the rusted-orange color mixture. Accent the edges and center of the petals using a mixture of yellow and white paint to make light yellow.

4. Continue defining each petal by adding pure sap green in the center of the flower. I brushed the color out lightly into the surrounding yellow of the petal and mixed small amounts of magenta into the green paint to create areas of deeper color. This can be used to help indicate overlapping and shadowing on the petals.

5. While mixing colors, reference the color swatches I made that show the range of colors I saw and used in producing this image.

6. Fill in the reds of each petal, using cadmium red as a base color. Create shadows with deeper red and browns in areas where the petals curve or overlap. Darken cadmium red for shadows by adding small amounts of sap green, magenta, and/or burnt sienna. You'll also need to add lightness and vibrancy to the petals, indicating the flowers' light source. In these areas, add cadmium yellow, cadmium orange, and

white to cadmium red. Through adding contrasting light and shadow, you'll define shape and dimension in the petals.

7. Define the background. Create the deepest shadow tones by combining burnt sienna, magenta, and sap green. Make the shadow color more green or more purple depending on its location (study the reference photo to find where the colors are located). Define the stems using sap green as a base, adding white to create a light green in central, highlighted areas.

8. Loosely define the color and shading of the background tulips using the colors on your palette. Since these flowers are out of focus in the photo, feel free to paint these flowers more loosely than you did the foreground flower. Think of your mark making similarly to how you added paint in the earlier blocking-in exercise (see page 42). As you work, aim to keep the focus and vibrancy of the colors strongest on the main subject to support interest in the overall composition.

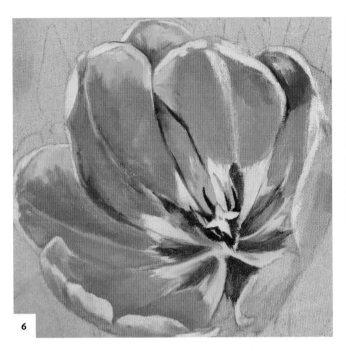

6

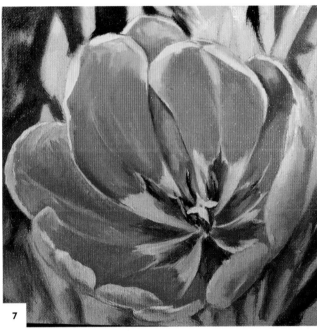

7

8

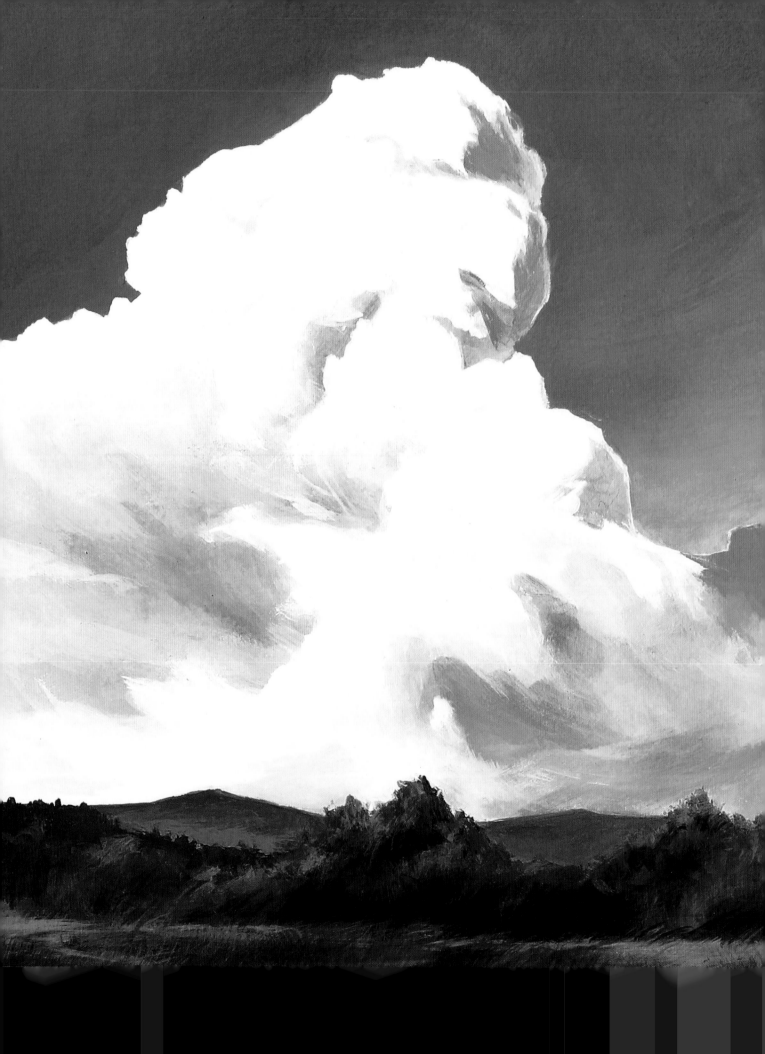

INTRODUCTION TO LANDSCAPE

Arrive, wiggle, and get loose!
In this chapter you'll learn to capture natural beauty
and suggestive detail in your landscapes.

I began painting landscapes in response to loss and a creative compulsion to connect with home. There was so much to learn once I arrived on the scene. Landscapes have opened my eyes to more thoughtfully study and interpret the visual world around me. Working in this genre surpassed my rigid approach of referencing photos and allowed me to find new painterly character in the organic play of natural beauty. Landscapes also taught me to think beyond a single subject matter to create compositions with perspective and layered visual elements. These skills felt refreshing to learn and strengthening to conceptualize.

In learning to interpret scenes in this chapter, you'll begin developing your own stylistic approach to rendering images.

One of my landscape artist role models is Eyvind Earle, the background illustrator of the Disney movie *Sleeping Beauty*. Viewing work from his career, I was impressed by the way he created tricks and go-to visual moves to remix into his work. He developed individual character styles for his clouds, trees, and mountains and often showed perspective through dramatically layered fore, middle, and background elements. Earle helped me question my personal approach to landscape depiction and whether I could build go-to tricks of my own. Deconstructing and simplifying a scene has become much more achievable since this revelation, and I'll happily pass my discoveries on to you.

NOTE *I created these paintings after I began studying Earle's work.*

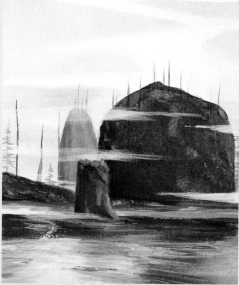

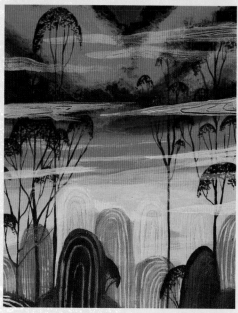

lesson 3:
THE FIELD TRIP PROJECT— PLEIN-AIR STUDY

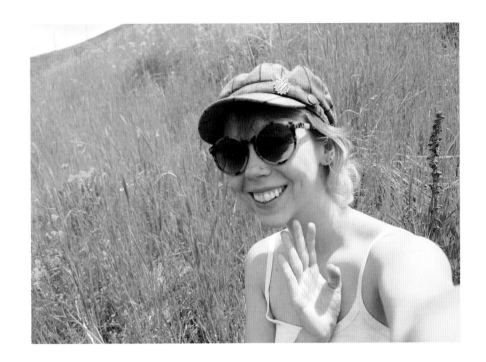

Aye, thar she goes! Here's a plein-air season Robin waving at you from a late spring field. I love art field trips, and it's time we took one together. In this lesson you'll step outside and create three fast drawing warm-ups, followed by a plein-air oil painting lesson. I started mine outside and finished it in my studio.

Working *en plein air,* or in the open air, refers to outdoor painting. Plein air links to the work of 19th-century French Impressionist paint-ers, whose work is best known for capturing light, movement, and color in ephemeral outdoor scenes. Working live this way, responding to sun-cast shades across a landscape, inspires distinctive color and brushwork in paintings. Think of this practice as conducting field studies steeped with visual information to observe and learn from. This is a direct way to transcribe nature from life to paper through your artistic hand. Painting a scene while actually in it is a unique physical experience, and it's an interesting challenge to flatten the dimensional space ahead of you into thoughtful line work and color-work. Shall we try?

Follow along with my work to learn line simplification and color choices from the reference photos and then take your own field trip. Find a scene in your own environment to sit in and work from life. Your field trip location can be as exotic or as tame as you choose. This field trip is your own design, so have a very pleasant time.

DRAWING WARM-UPS

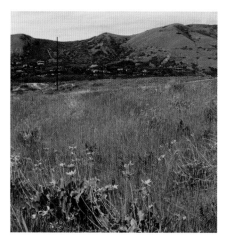

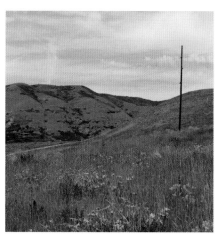

NOTE *I arrive on the scene of a local outdoor hub, an access trailhead with ample fields to sit in.*

WARM-UP 1: SIMPLE, TWO-COLORED THUMBNAIL SKETCHES

1. After choosing my first location, I retrieved a yellow crayon from my satchel and boxed out two thumbnail squares—moderately small square outlines—to house my drawings in my sketchbook. One scene was directly ahead of me, and the other was to my side. I spent a few minutes sketching each in crayon. Keep these drawings fun and fast—thoughtful, but not aimed at perfection.

2. I went over the scenes in pencil, selectively defining lines of elements such as the mountains and larger plants in more confident, visible line work. The color contrast of crayon and pencil allows for drafting layers, moving from general impression to higher definition.

TIP *It's normal for plein-air paintings and reference photos taken on site to look different from each other. Don't stress over photorealism; plein air is about your lived experience with a scene.*

WARM-UP 2: PRACTICING PANORAMAS

1. I created a wider, thinner composition using a light-yellow marker and taking in the strip of landscape encircling my periphery. I drew lines for the hills and telephone poles as relevant place markers and then sketched the center tree, followed by middle and foreground shrubbery.

2. I used pencil and green and purple crayons to further define the landscape. I increased definition and visual information while exploring some line quality and landscape feature simplification, redrawing lines in new colors to refine my original marks. After this drawing warm-up, I'll create a sketch for my painting, so at this stage, I want to think of color and form as a warm-up.

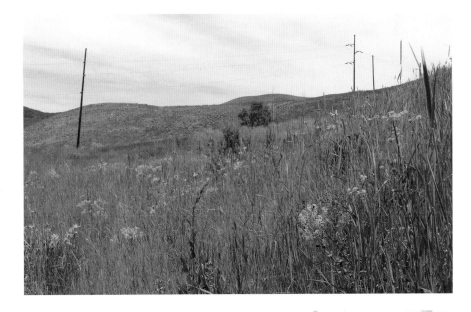

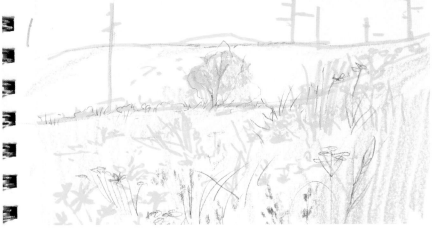

Plein-Air Drawing Tips

- Close or cover one eye to flatten the scene. Notice that if you switch between closing one eye, then the other, the scene moves slightly. The offset perspective of your eyes can be distracting when transforming 3-D space into a 2-D image.

- If you feel uncertain about placing lines on your paper, hold a pencil up to the scene ahead of you and measure angles and distances against life, then against the paper. This is helpful in refining simple, key line work, which is indicative of perspective.

- Begin your composition with the horizon line if you don't know where to start. The horizon line determines where all the other elements of the scene are placed in the thumbnail box.

- If you're struggling while sketching your composition, take a quick photo of the scene as a reference. If you're used to working from photos, live drawing can feel awkward at first, but you'll learn with practice. Observational drawing is a great skill to hone. You can practice by tracing distant objects with your eyes or finger in the air.

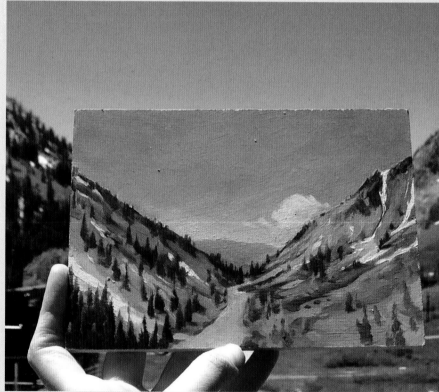

PLEIN-AIR PAINTING STUDY

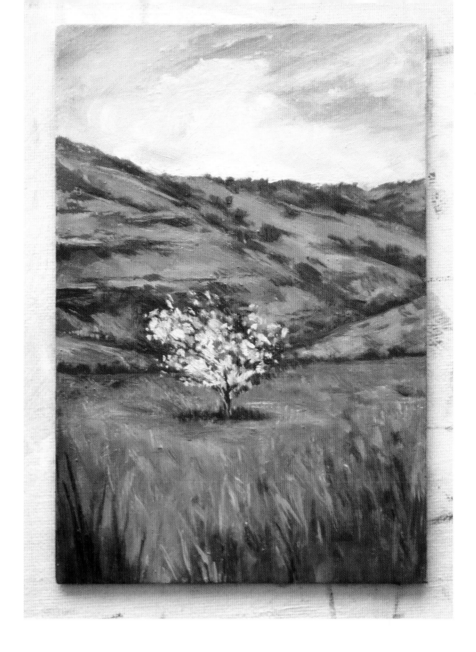

NOTE *This is typical of what my plein-air setup looks like.*

Find a good place to settle in for a long work session. I've learned the importance of finding a good location and shaded areas from various past outdoor art excursions. When painting outside, you're a guest in the environment you choose, and weather, insects, and various other physical considerations come into play. I found a beautiful shady tree off a major path that had excellent shade and a great view.

The limited materials I brought for the trip included a 4″ x 6″ (10 x 15 cm) primed MDF panel; white, yellow, phthalo blue, and magenta oil paint; four brushes (a small angle, flat, and filbert brush and a medium-sized flat brush); Liquin; a paper towel; and an improvised palette made from a plastic-wrapped canvas board. If you can't get outside, use the reference image on page 123.

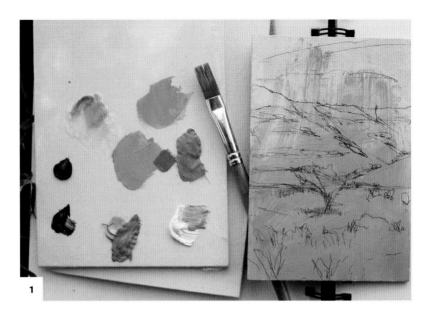

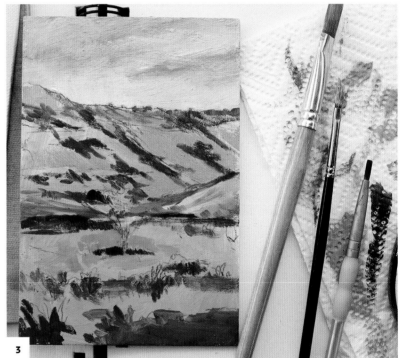

1. Mix a mint-yellow color by blending white, yellow, and a small amount of phthalo blue. Add medium to a medium flat brush to create the desired pull and thinly and loosely apply the base color to the panel. I applied the paint to the bottom three-fourths of the panel, where green appeared in my scene.

2. Lightly and loosely sketch the scene on top of the thin base color with a pencil. Begin and focus the drawing around major compositional elements such as the central tree, horizon line, and the top edges of the background hills. Background elements should appear smaller and less defined, so avoid getting lost in them. Refining the details will come later in the painting.

3. Painting this image felt like conducting an orchestra. Some oil painters layer color from dark to light, strategizing tinting colors lighter so they finish with highlights in the brightest hues and whites. But this painting pulled my color sense in many directions, and I went with it.

Define prominent shadows in the tree and shrub lines, carving out negative space around the far horizon with a light-blue skyline. Block in the scene with neutral beige hillsides and greens in mint, lime, and deep seaweed for shadows.

4. Increase surface coverage and color range, filling in the greens for the shrubbery and adding hints of purple and blue for the mountainside shadows and foreground field flowers. Notice that in my painting I created hillside shadows with a shade of purple that leaned more magenta and

Color Swatch Guide

SKY: Use white and phthalo blue for the background blue tone. Create cloud definition by using white in highlighted areas and a small amount of magenta to create muted purple shadowing.

HILLS: The light beige is made by blending all four pallet colors. Start with white and add warmth with yellow and magenta; then, mute and dampen it by adding a small amount of blue. This builds up color definition and initial layers.

TREES AND SHRUBS: Create a medium green by blending blue and yellow. Create dark greens by adding more blue to the mixture or by adding magenta to make the color even darker. For a yellow-green hue, use more yellow than blue in the mixture, and for a light mint green, add white paint.

painted flowers in the foreground with a bluer hue. Fill in the light-colored grass in the foreground field with the light orange/beige used for the hill.

5. Increase the contrast and definition in the hill, tree, and field. Layer colors and use thoughtful brushwork to add textural contrast between the smoothness of the hillsides and the dense texture of the grass. In this step you'll develop the image from the initial block-in to a more fully developed scene. Carve the neutral hillside with painted detail to define distinction between the curving features, the sunlit hill face, leafy brush, and shadow. Use a small round brush to

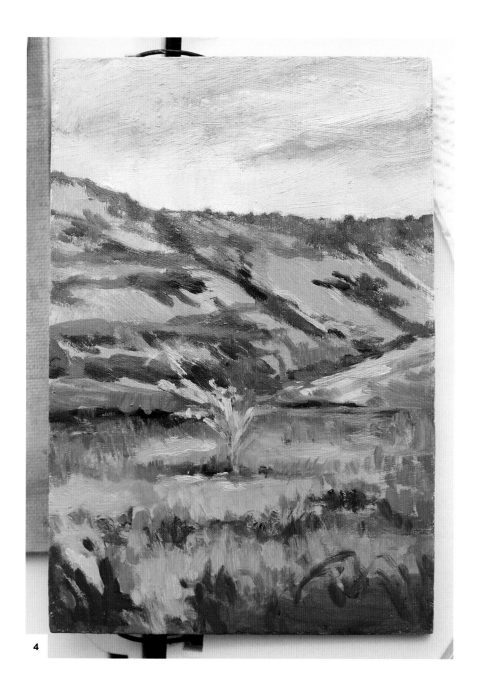

4

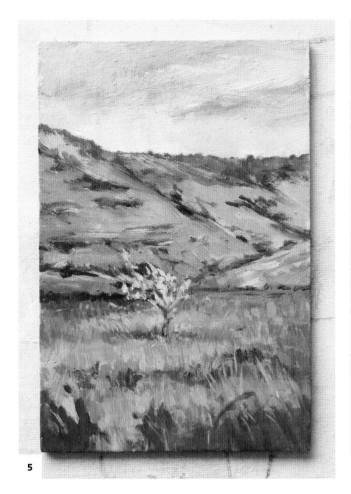

5

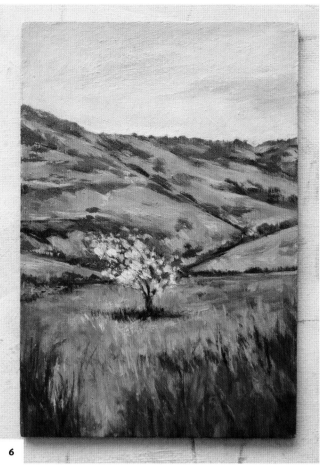

6

add thin line work and detail to the trunk and branches of the central tree and thin blades of nearby grass.

6. Continue to adjust and build layers of color. Add opacity to the sky by mixing white and ultramarine blue to form a light-blue sky color that you'll use to shape negative space around the clouds; then, define the tree and shaded foreground grass. Use a medium green color on the hillside to further define distant trees and brush, as well as to carve negative space surrounding the middle ground tree. This will help its white blossoms to contrast against the hill. Further contrast between the dark foreground greens and lighter sunlit features of the middle ground field by adding dark, upward dashes of green at the very foreground of the image.

At this stage, I worked on the painting in my studio, using a reference photo. I didn't use the photo as a strict guide, since I wanted to maintain the essence of the landscape that I enjoyed painting live.

7. This is the magic step. I ditched my reference photo and defined an imagined cloud formation emerging in the sky that reminded me of the animated background scenes in the film *Howl's Moving Castle*. Take artistic liberty with your art when you have stylistic, image-enhancing ideas to add to a scene. I heightened the color contrast and detail work with saturated green color glazes over the grasslands, deepening the green shade range and adding white tree blossoms and high-lighted cloud shapes. (See the finished image on page 65.)

lesson 4:
FAST LANDSCAPE DRAWING— SAMPLES AND EXERCISES

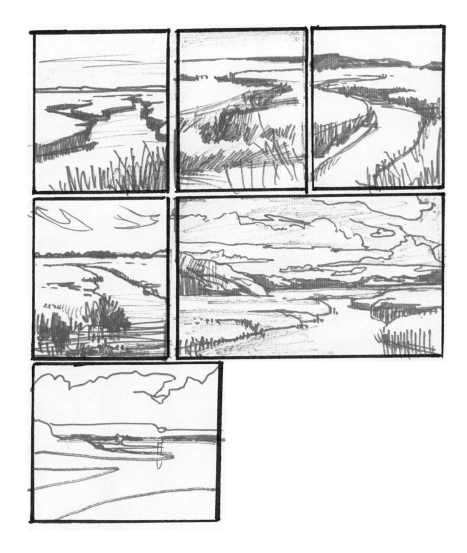

Let's review ways to simplify the landscape and then practice with some warm-up exercises. For these landscape exercises, think less about detail and more about zoomed-out, simplified composition. If you were to squint at the scene, blurring your vision, what are the essential things you might still notice? Here you'll learn to break landscape down to its most important parts to begin mastering drawing and painting it.

In landscape drawing I like to use delicate, loose, and simple line work, aiming to depict suggestive form without getting too detailed. Details are great, but a common mistake beginning artists make is getting lost in them. As you move through this project, think about the image as a whole, considering where lines exist in relation to one another, the comparative angles in land features, horizon line heights, and other big-picture compositional features.

EXERCISE 1: FOUR SIMPLE LANDSCAPES

Using the sample photos and paired drawings for reference, create four simple landscape drawings in pencil:

- A river bend perspective drawing

- Clouds over mountains

- An ocean scene

- A tree-lined road scene

While drawing, pay particular attention to the following:

- Outlining and mapping major compositional elements

- How perspective pinches and flattens distant visual elements

- Using shading thoughtfully to indicate form and definition

- How defining simple features can be used to improve drawings and inform your sketchwork for future painting preparation.

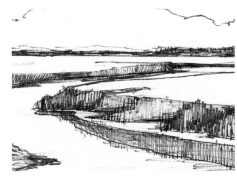
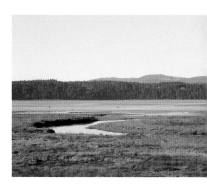

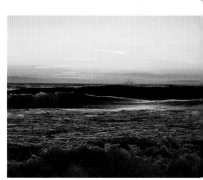
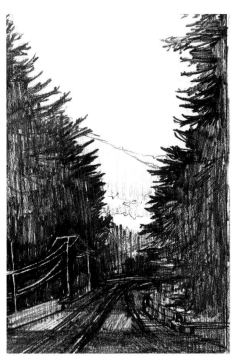
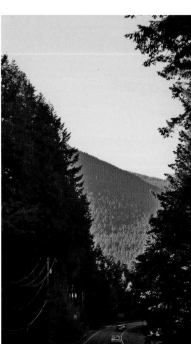

EXERCISE 2:
SIX TINY LANDSCAPES

1. Create six 2″ to 3″ (5 x 7.5 cm) squares and draw a group of tiny landscapes. This exercise is similar to making thumbnail sketches (small, abbreviated drawings done with little corrective work). Add shading and detail as you wish, but if you start to overthink a sketch, set a timer for five to ten minutes, focus on general shapes and composition, and see what you can do in a short time frame.

Increasing creative constraints through limiting project size and/ or time is a good way to remove the pressure of perfectionism.

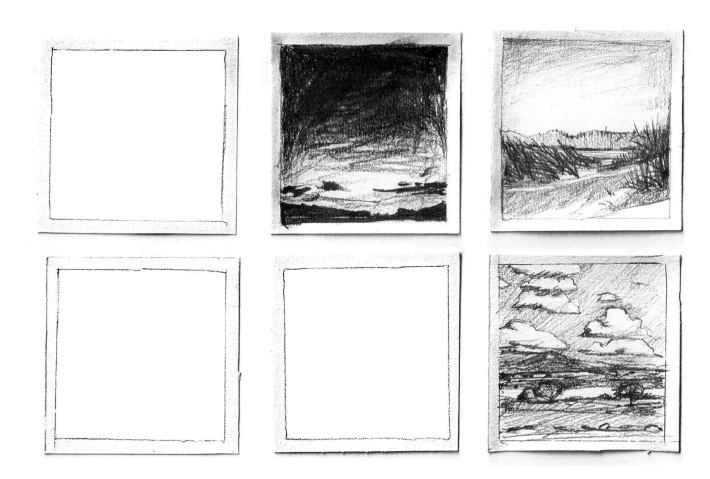

RIVER PERSPECTIVE— DRAWING AND PAINTING

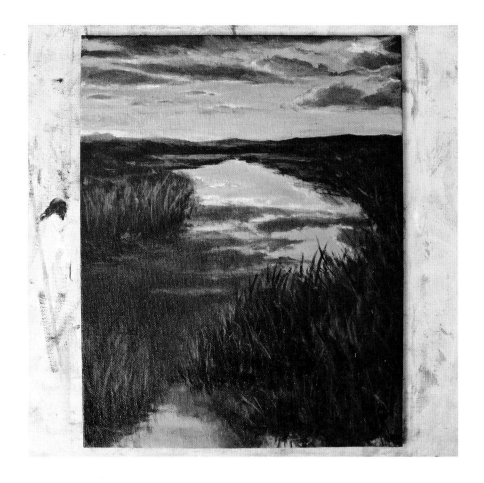

In this project you'll create perspective in a landscape through the handy visual feature of a winding river. This is my favorite way to demonstrate how receding space appears in a two-dimensional image. The archetype of this river perspective scene is so remixable and reproducible that for this lesson I made a mockup image of my own creation for the reference image. I'm feeling pretty excited about this, so let's get started.

DRAWING WARM-UP

Before you begin, explore the four sample thumbnail images. At top-left is a simplified version of the painting composition, and the other three are similar simple renderings of marsh scenes. Practice drawing river perspectives with your own four thumbnail drawings to prepare for making your final work and keep these guidelines in mind:

- Approximate or measure with your pencil where to draw a horizon line.

- Mountains, tree lines, or objects in the distance should be small, compressed, and carry few details.

- Define the shape and edges of the river by placing grasslands on either side of the waterway. The distant parts of the river should appear

flatter and more squeezed toward the horizon, with water bends winding more loosely and dramatically as they approach the viewer.

- Consider creating cloud shapes in the sky and reflections on the water.

PAINTING PREPARATION

1. I used markers to create a simple drawing guide to follow for drawing the composition onto the painting surface. For this project, I used an 8″ × 10″ (20.5 × 25.5 cm) canvas board. The green lines in the colored drawing represent the land structures, and the yellow lines show the sky and reflective water.

2. I transferred my final drawing from paper to canvas board in my final preparations for painting. Think about how you'll prepare your image.

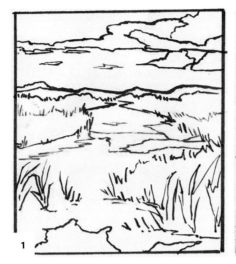
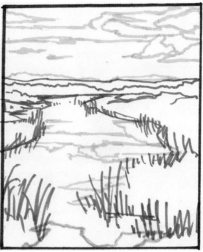
1

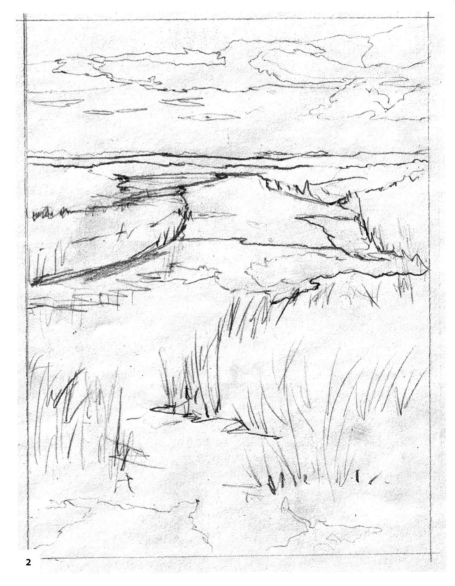
2

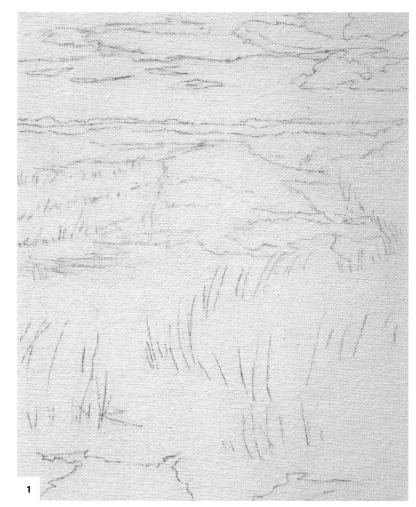

1

CREATE THE PAINTING

1. Since you've done some painting preparation, this step is brief. I used a mixture of white and yellow acrylic paint and painted a fast-drying base color, allowed it to dry, and then created a transfer drawing over that layer using a brown Prismacolor NuPastel Color Stick.

2. The first color family you'll work with is a range of tinted, shaded, and muted blues. The lightest areas of blue depict the pale blue sky and its reflection in the water and are made using a mix of white and ultramarine blue. Also reflected in the water is a medium blue color, representative of the dark clouds. Mix this color using white and ultramarine again, creating a darker blue mixture. The deepest shaded areas will define shape and depth in the grassland. To create this shadowy blue, mix orange into ultramarine blue to deepen and mute the color. To adjust any of these hues, remember that adding white will tint (or lighten) colors and magenta can be used to deepen shadows and push the hue more toward purple.

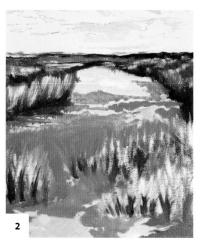

2

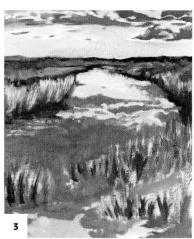

3

3. Introduce warm brown and light-yellow paint into the composition, colors created by the light source on the left side of the image that's

throwing warm light across the scene. A light peach-yellow fills the bottom-left side of the horizon, fading to light blue on the right. Mixed orange,

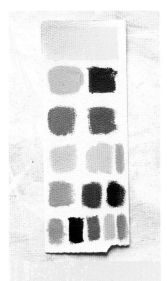

Painting Color Swatch

This color swatch represents the colors I used to create the image before its final glazing stage.

I introduced these areas of color starting from the yellow block at the top (the background color), moving down in order to the smaller color row at the bottom, which are hues I used in late-stage detailing and light adjustment.

ultramarine blue, and white paint will create warm orange light, blending into the gray-blue clouds in the sky and reflection. Yellow and magenta can be added to color mixtures made in this step to create additional warm peach tones in the clouds.

4. Introduce green for the grass. Sap green is an excellent base hue. This color can be used later as a glaze to add an accentuated deep and vibrant color, but for now, mix it to create various shades of grass green by adding white and small amounts of magenta for hue variety. Reference the images to see how I began to layer color in loose, vertical brushstrokes, adding grass blades and suggestive detail in the grassland.

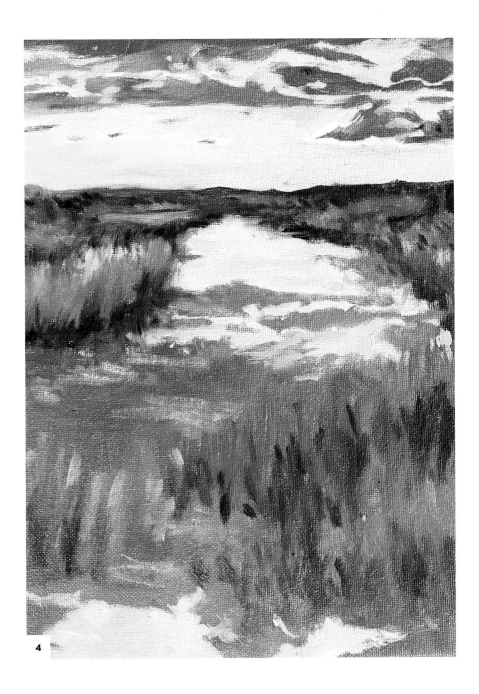

4

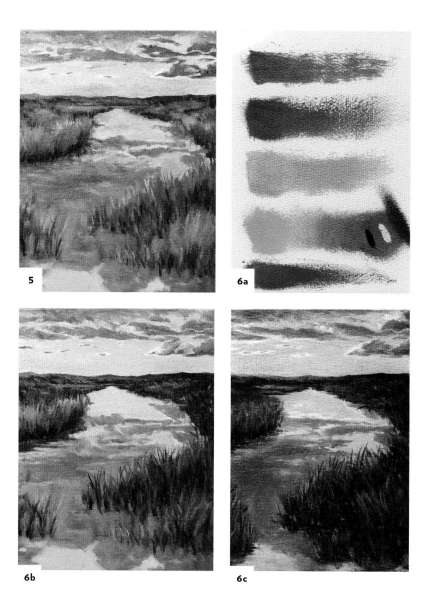

5. Instead of painting every individual blade of grass, make repetitive long and upward flicking brushstrokes, creating the textural illusion of layered greenery. Vary bush sizes and shades of light and medium green as you block in and detail the grass areas, producing distinct highlights on individual blades sitting closer to the foreground. Create medium blue by blending white and phthalo blue paint and use it to add the glowing blue color found dispersed in areas of the grass and reflected clouds.

6. The first image shows my painting before final opaque color layering, glazing, detail work, and contrast pushing. These are general tweaks I'll make to bump up my color saturation, brightest lights and darkest darks. The swatch panel includes the glaze colors I used to finish the image. The brown-greens are mixed using primarily sap green with burnt sienna; the gold is a light-yellow mix of white, yellow, and burnt sienna; and the blues are a mix of white, ultramarine blue, and some phthalo blue for brightness. Glaze colors are made with paint diluted with medium and thinned to greater transparency in areas where hue adjustment is desirable, but losing underlying detail is not. I use glazes to fill in green grass hues with thin sap green paint, warm up light in the sky on the left with saturated yellow tones, and darken shadows in cloud reflections and dense grass, selectively layering in thin ultramarine blue and magenta shadowing.

lesson 6:
SUNSET TREE SILHOUETTE— SCENE PAINTING

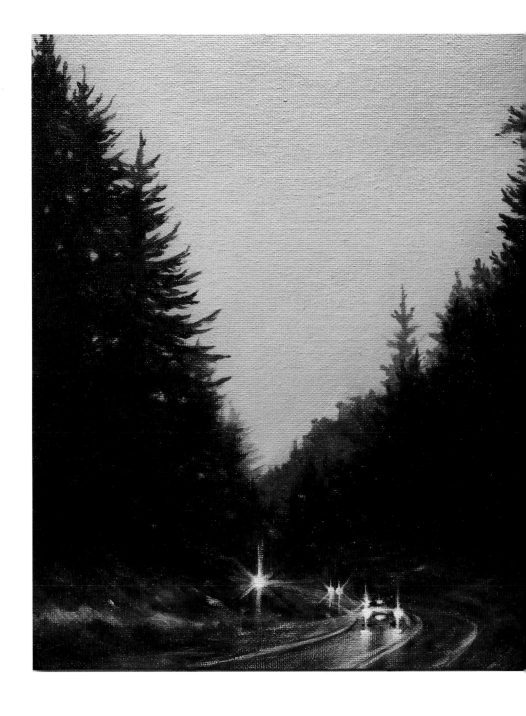

Building on your growing understanding of depicting perspective through winding outdoor spaces, this project reinforces concepts from the previous lesson while playing with some of my favorite landscape features: colorful graduated skies and delicate, silhouetted forms (see the reference photo on page 123). Let's hit the road with this painting.

1a

Painting Color Swatch

This color swatch represents the colors I used to create the painting.

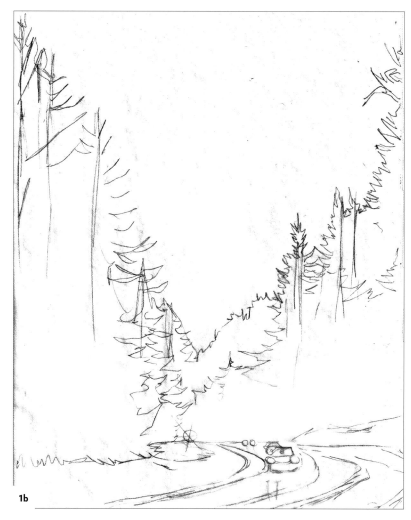

1b

1. Choose how you'd like to prepare your painting. I used a mixture of white, yellow ochre, cadmium yellow, and rose acrylic paints to set a fast-drying peach base color and allowed it to dry. I created a transfer drawing over this layer using a brown Prismacolor NuPastel Color Stick. (For more information on creating a transfer drawing, see page 38.)

2. The first color family you'll work with is a range of burnt oranges for the tree silhouettes. Layer the smaller, more distant center trees first. Combine cadmium orange, burnt umber, and burnt

sienna to create this rust shade. I used a small flat brush to shape the trees; make sure you think about the tree forms as you paint. These evergreen silhouettes have tall, thin central trunks and pointed branches that reach up in soft diagonals toward the sky.

3. Pay particular attention to the size and shape of the brush you use to paint in the delicate branches extending into the negative space of the sky; I used a small flat brush. The small, distant trees will be lighter in color and less detailed because of atmospheric

perspective, which gives distant objects a hazier appearance. Adding sap green to the rusted orange from step 2 darkens the color and gives it a green-brown tone, useful for blocking in the larger, closer tree silhouettes.

Remember the shapes and silhouettes of evergreen trees as you work. Again, think of your marks as tall trunks fanned by branches that swoop outward and upward. Referencing images while creating silhouettes is useful for rendering the natural and unique species characteristics. Recalling the form of what you're painting informs how you apply brushstrokes. Suggestive detail is born in your painting by adding opacity through layering paint in directional brush-strokes dragged to match the curving bow of heavy tree limbs and short tick marks of grouped pine needles. Use this same guiding principle for brush-work and layer building to extend the red and dark browns into the grassy mounds flanking the road at the base of the trees.

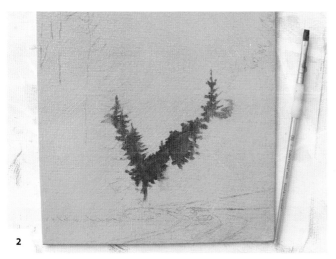

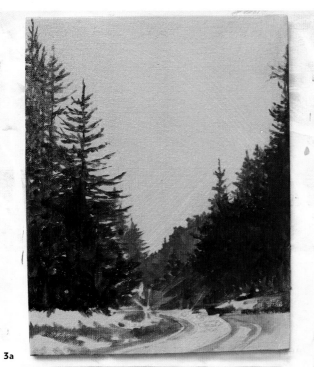

4. Use white mixed with black to produce gray for the road. Place lighter gray tints in the center of the road, near the reflective headlights, and darker gray at the front and sides of the road. This produces an appearance of shining, moist, and cool-toned pavement. As you increase contrast in the road and develop it through this step and subsequent ones, extend the gray color range by adding small amounts of magenta, purple, and/or blue paint. You'll add a lilac color to the sky in the next step, and those tones will be picked up in the reflective color on the road.

5. Work a thin gradient into the sky using a medium-large flat brush, moving from a sunny yellow-orange in the lower horizon color to a light lilac blue at the top. If the tree line paint is thin and dry, lightly brush the sky color over the borders where the trees and sky meet for an uninterrupted sky color. Later, paint dark shadow to redefine the branch edges. The day I took this photo, fires blazed in Oregon, making the air glow orange, but I wanted to use artistic license to add other colors to the sky. I mixed a range of pastel hues and used them to create a gradient from orange to lilac. The colors I created were a peachy-yellow made with white, yellow, and orange; pink made with white and magenta; light blue made with white and ultramarine blue; and lilac made with white and purple. I also used medium to thin and blend my colors.

Smooth a warm yellow sun glow into the distant tree line at the horizon. Moving up the composition, add pink, lilac, and light blue at the very top and center area of the sky. Use these sky colors to bring light into the foreground and middle ground. Working with a small flat or small

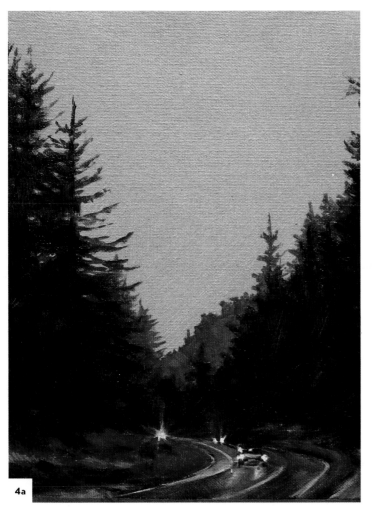

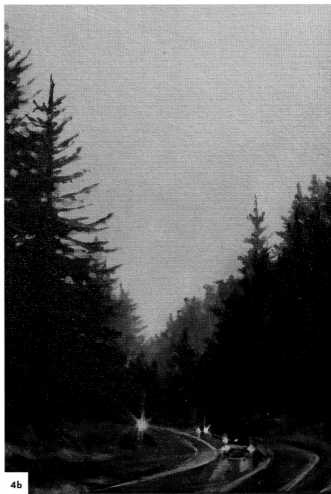

4a

4b

round brush for detail work, emphasize highlights and reflective color, noticing how light bounces off the road onto the surrounding landscape. Light should emanate in thin beams from the front car, becoming starbursts around the headlights. The sunset glow and car lights glance lightly off pine needles that border the slick road in the middle of the composition.

6. Equipped with a palette filled with an array of color mixtures, add details to the image. Go over any silhouettes that have been muted by the sky gradient, deepen the shadows, dramatize the light flares with final color contrasting and finessing, and add layers of dark color to the forest. This is where you make the magic happen and give the scene personal spark (see finished image, page 77).

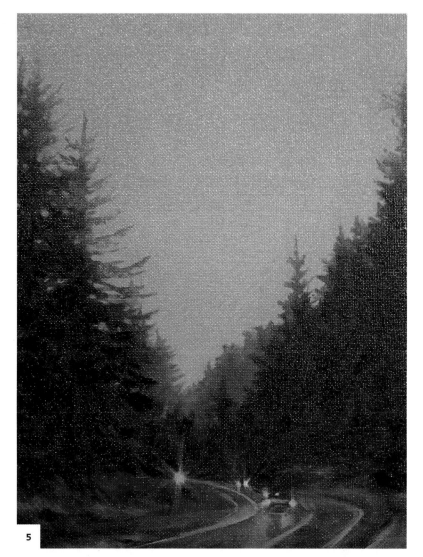

5

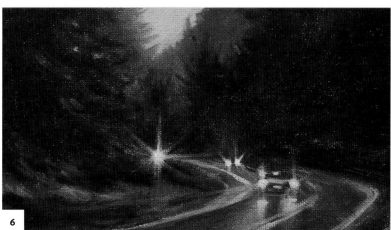

6

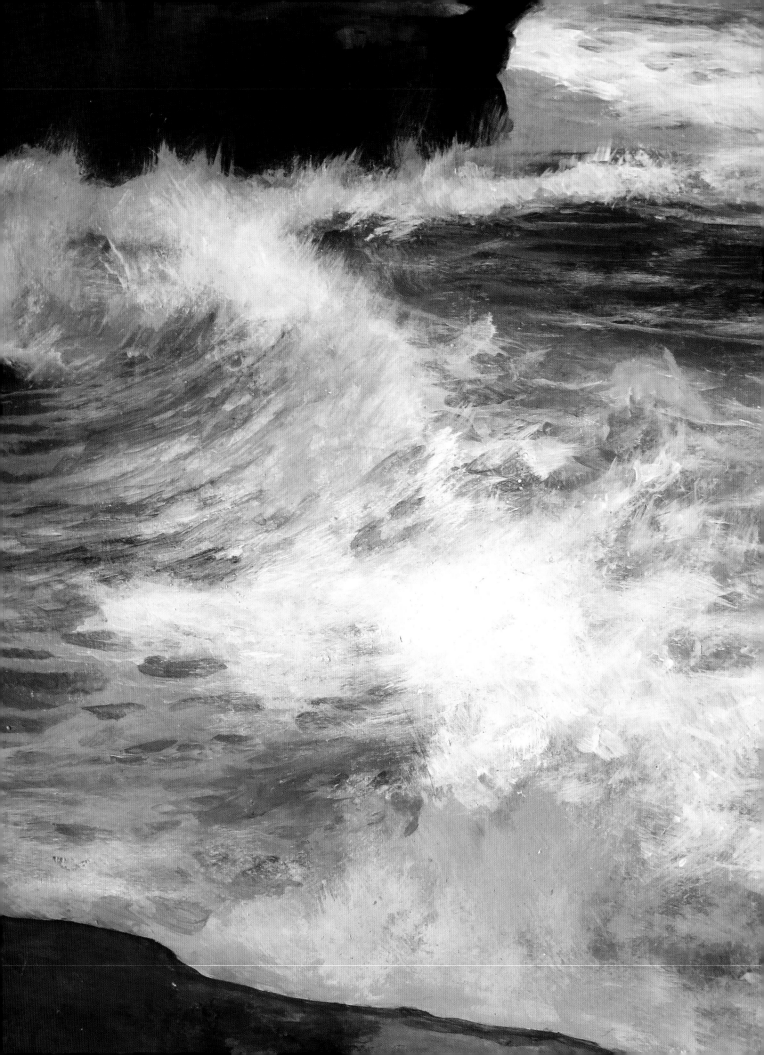

ELEVATING SCENES

Elevate your work with magical artist steps into rendering atmospheric perspective, composition, and fine detail.

In any enduring artist's voyage there comes a point where a great leg of the journey is complete, promising shores lie distantly ahead, and it comes time to stop and sniff the sea air with gratitude. Appreciate the finer things in this chapter as you elevate your work with a touch of finesse. Building on your knowledge base, you'll bring a celebratory flare, style, practice, and charm to establish a unique presence in these next paintings. Step through each work with me, inspiring yourself to joy—adding touches of light, paying attention to color, and heightening detail. This is your chance to make water shine, make fields glow, and layer lush foliage.

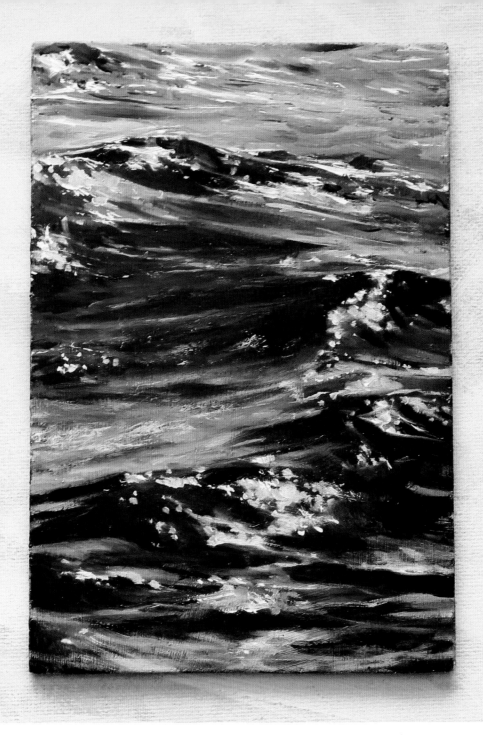

lesson 7:
WAVE REPLICA PAINTING

In this lesson, you'll paint a replica of a wave, working side-by-side with a reference photograph. You'll review how to measure important compositional distances and angles as well as practice a color matching technique to build your skills in photorealism.

DRAW THE WAVES

1. Prepare a 4″ x 6″ (10 x 15 cm) surface to paint on. I chose to work on MDF board (medium density fiberboard). I prepared the surface by applying three layers of gesso, sanding between layers after they dried with fine-grit sandpaper to avoid creating scratches on the surface.

2. Place the painting surface beside your reference photo (see mine on page 89) and use a ruler or a straight-edge to mark out the height of significant wave forms in the composition.

3. Use your tool to measure both the heights and widths of waves. To do this, measure the distance from the edge of the image to the peak of a wave and then mark that distance on your drawing.

4. While you're making the measurements or afterward, connect the marks you made on the surface to fill in any curving angles and sides of the waves.

5. In addition to indicating wave forms, measure and mark locations of significant shiny areas on the water. This will help you later to position your brightest whites.

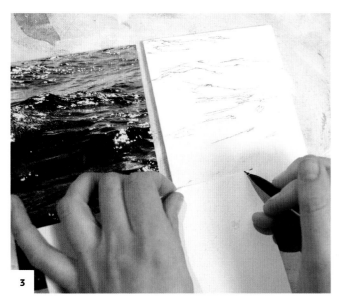

1

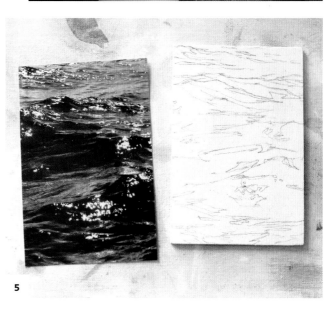

2

3

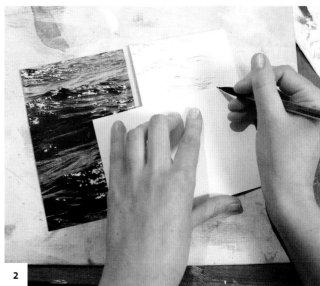

5

PAINT THE WAVES

1. Create a semitransparent green-blue glaze for the base layer. This base provides an initial degree of color coverage upon which you'll develop a full color range. For this glaze, mix ultramarine blue, sap green, and quinacridone magenta. (This paint color will be used in later steps as well.) By adding small amounts of Liquin to the paint, you'll decrease the opacity of the pigment. Experiment a little with Liquin and

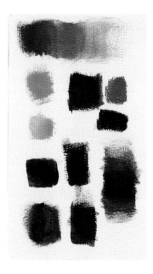

NOTE *I made color swatches for this painting to demonstrate the hues and shades you'll mix. This lesson, when broken down, becomes a straightforward process of mixing colors and filling in the drawing. You'll do this in a series of layers and steps in order to ensure a dimensional, finished, and lifelike image.*

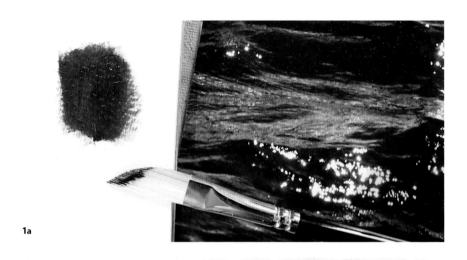

1a

1b

3a

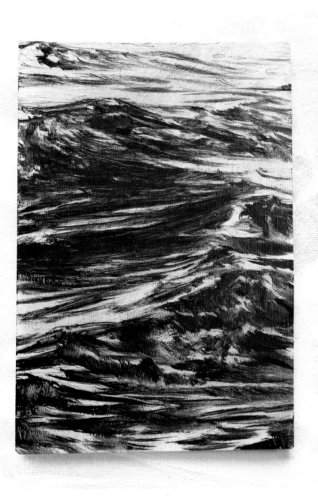

2

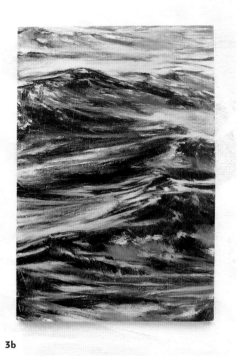

3b

paint proportions in order to get a thin layer of color that you'll apply over your drawing. Consider applying the thinned paint with a paintbrush that's large enough to provide quick and easy coverage.

2. Fill in the darkest areas of the wave first. This can be done with the color you mixed in the previous step, though this time, add less Liquin. Liquin may still be useful if you need to adjust the thickness or drag of your paint—just be careful not to decrease the opacity of your paint too much. In mixing additional paint color to complete this step, my

darks moved slightly more blue than our original glaze color, but still came out nicely.

3. Fill in the light and mid-toned areas of the water to finish establishing the image structure. I used lilac (mixing purple and white) in the negative spaces left between darker paint areas and used light blue (mixing ultramarine blue, purple, and white) as a transitional mid-tone and to help indicate areas of reflective light.

4. Increase the contrast by deepening shadows with green and blue and adding white highlights.

TIP *I work with my materials conservatively at first, adding more as needed. This helps me avoid messy, slippery, thick paint layers, as well as waste.*

Note that the details will be pushed back in step 5 before you bring them back with flourish in step 6. For now, use a small brush and short strokes

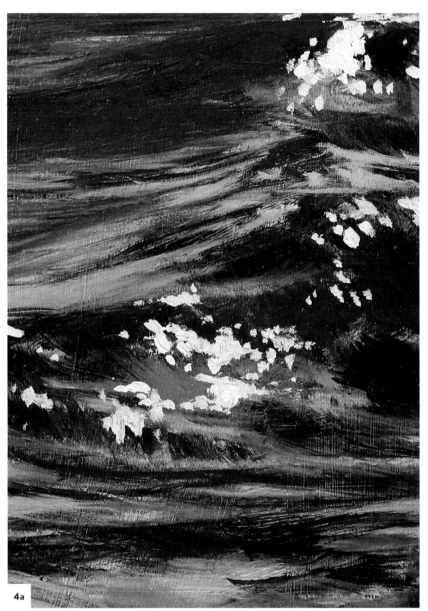

4a

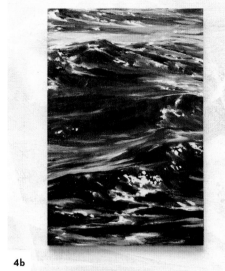

4b

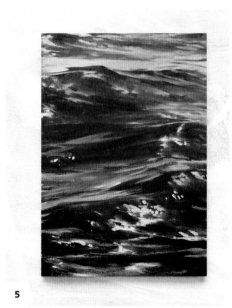

5

of dark green (made by mixing primarily sap green and ultramarine blue, adding magenta if you want to mute or deepen the color) in the shadows and pure white paint in the areas that shine.

5. Lightly brush the surface with a dry, clean, soft flat brush. The goal is to dry brush the surface to soften the whole image. Be thoughtful about brushstroke direction and intentional blending, working with the horizontal, directional flow of the waves. This can seem a little scary, but the method is useful in general oil painting practice for softening color transitions or gradients and proves very useful.

6. Begin adding back details and continue to increase contrast. I worked in a similar way to the technique in step 4, deepening shadows and putting in more crisp white highlights. I used small, deliberately placed white dots to show glistening light as well as scratchier, dragged, light-handed brushwork called scumbling (see page 30). I did the latter technique mostly in lighter, mid-toned areas to create the appearance of light sweeping the surface of the water. (See the finished image on page 84).

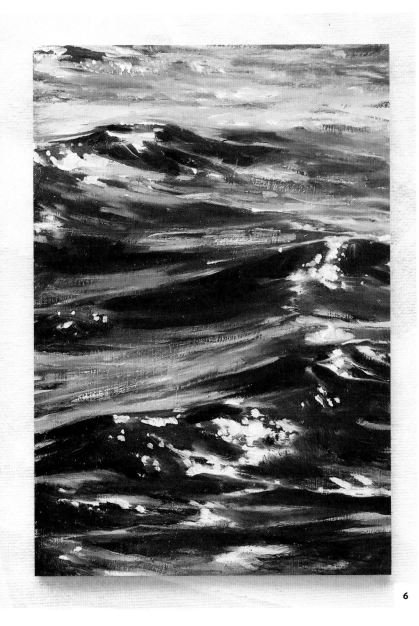

6

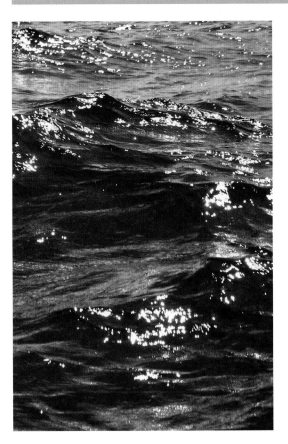

Unifying Paint Colors

Contamination among paint colors can be controlled by keeping an organized palette and cleaning brushes between color changes, but some intentional cross-contamination between mixed colors may be useful. When mixing colors for a painting, consider incorporating either bits of blended colors already on your palette or the remnants of paint left in your brush into new paint colors. This can prove advantageous in unifying the hues in your paintings.

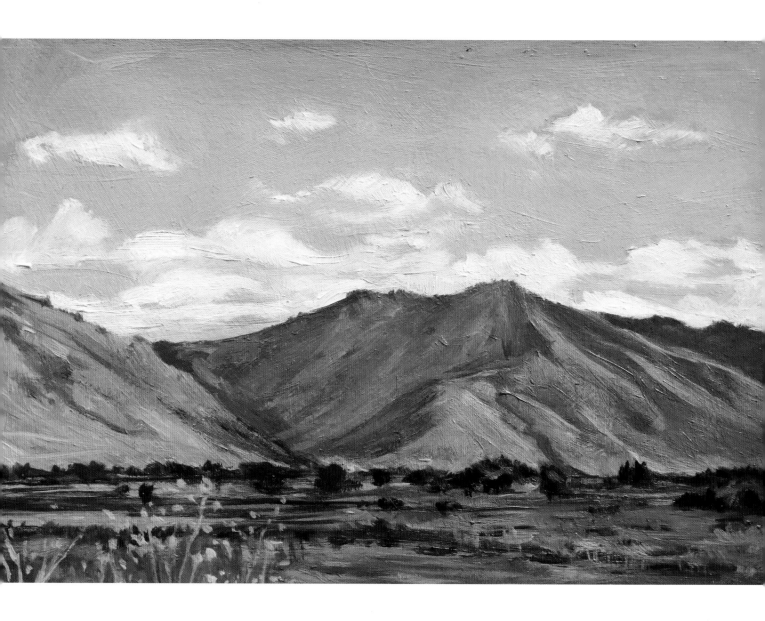

lesson 8:

GREEN FIELD AND MOUNTAIN SCENE PAINTING

This landscape painting uses fast and simple sketchwork to get started (see the reference photo on page 124).

1. Tape off a 4″ x 6″ (10 x 15 cm) rectangle on a piece of primed paper. (I worked in a sketchbook.) Make a loose, proportional sketch of the reference photo. When drawing, pay attention to where important lines fall in the composition: the base of the clouds, tops of the mountains, where the grass and tree line meet, etc.

Simplify objects into basic shapes: Create a flat horizon line in the bottom quarter of the image, a circle for a bush, and a bumpy line for treetops in the distance. Along the way, use your pencil to measure structurally guiding angles and lines found in the field, horizon, and mountain.

2. Mix small amounts of white and phthalo blue to produce sky blue. Create a subtle gradation moving upward from a light horizon line to a deeper blue sky on top. Leave white space for painting clouds later.

3. Blend French ultramarine blue and small amounts of orange to the sky-blue mixture to create shadows for the mountain range. This will darken and desaturate the original mixture. Add Liquin if needed and add the shadows to the painting.

4. Referencing the color swatches as a guide, use burnt sienna, orange, sap green, white, and ultramarine blue to create a few muted tones for the sunlit portions of the mountain. Some of the hues I created in this step were cool light beige, warm light brown, pale aqua, and lilac. Dampened tones used throughout this step create atmospheric perspective, where distant objects appear hazier than those in the foreground. Reserve the brightest hues for the foreground.

5. Establish the dark green tree silhouettes at the mountain base using sap green and French ultramarine blue applied in small, ticking motions for a thin, slightly bumpy textured tree line. The middle and foreground field use more saturated greens hues,

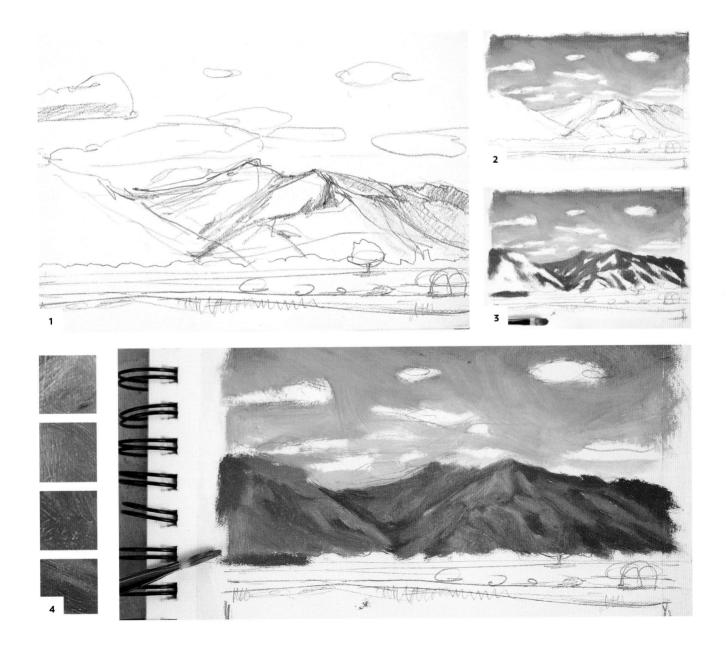

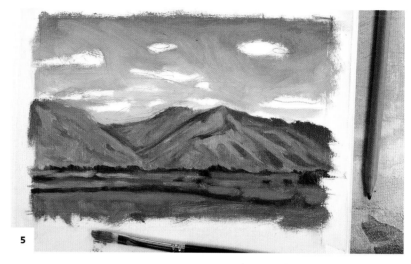

5

including phthalo yellow green. As
noted previously, foreground objects
should appear more saturated and
contrast-filled than background
objects to emphasize atmospheric
perspective in the composition.

6. Remove the tape carefully to not rip
the page or smudge the drying paint,
and then take a good look at the paint-
ing. Add any additional details and
color adjustments you desire. I took
this opportunity to adjust a few things,
noted in the list below.

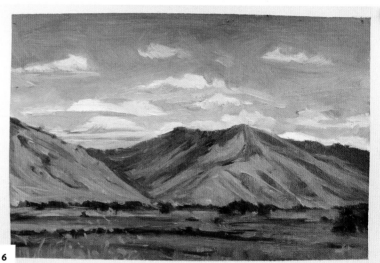

6

HERE ARE SOME FINISHING TIPS:

- Finalize rendering shape in the
 clouds and color in the sky by
 cleaning up edges and filling in
 opacity in the blues where thin
 paint with visible brush marks and
 background paper are exposed.
 Soften and blend the final layer
 with a clean, dry brush if needed.

- Hit the shadowed faces of the
 mountains with additional hazy,
 cool blue color to define contrast
 between the shaded and sunlit

areas. The mountain features
facing right are bathed in light, and
the ones facing left are in shadow.

- Increase the detail and contrast in
 the field area closest to the viewer.
 Nearby objects should appear more
 detailed, and now's your chance to
 make the colors really pop. Define
 the detailing of tree trunks, distant
 grass, and yellow foreground flowers
 with fine brushwork and clean color.

lesson 9:
FLORAL MARSH SCENE PAINTING

You've built your knowledge of atmospheric perspective, layering green tones, adding suggestive detail, glazing translucent hues, and building scenic beauty. Now that you have these skills, let's depict some of nature's most beautiful elements in this elevated scene. This marks my third time painting this scene, which is a marsh in New Hampshire viewed from a family member's backyard.

Before you start, critically observe the reference photo (see page 125). From the top down, from the farthest elements to the closest ones, the composition starts with a blue sky over a faintly hazy distant hill crowded with trees. A middle ground strip of warm sunlit trees interrupts the background. These trees sit nestled in brush and grassland bordering reflective blue water. The horizontal strips of water (segmented by a land bridge) are overlapped by a line of trees sitting on the viewer's side of the marsh. Moving into the

lower half of the image, grass and plant life approach the viewer in lightly varying lines of green hues and texture. White-topped reeds and purple brush flowers take up the foreground. The foreground also includes deep foliage shadows, vibrant greens, and on the right, shadowy leaves of encroaching tree branches.

When painting these elements, remember the relative distance of features and the increasing saturation and contrast as you work toward the foreground. Reserve deep colors and higher detail rendering for those closer areas.

1. Here's a teachable transfer-drawing moment: Notice that on this transfer drawing, my lines are less defined than on other transfers. I chose a lighter Prismacolor NuPastel Color Stick, and after transferring the image, I brushed off the excess chalk. I used hairspray to fix the drawing and decided the lines were visible enough to work with, but note that this type of lightweight transfer can occur when trying different materials for a transfer.

2. Begin blocking in the light-blue areas using white and phthalo blue for more bright, electric blue parts of the sky. Add small amounts of ultramarine blue for purple-toned cloud shadowing. Light blue can be found in my sky, the reflective water, and lightly scratched into the lighter areas of grassland.

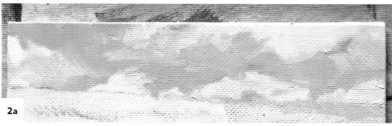

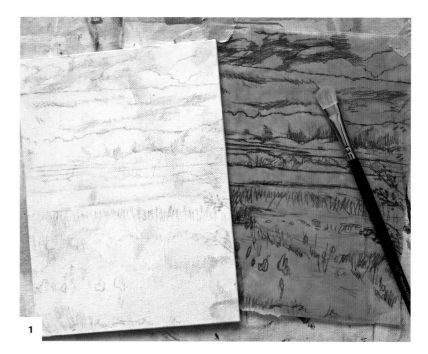

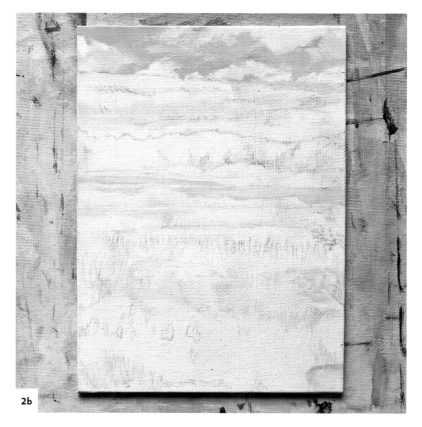

3. Work downward, blocking in the composition from the most distant features to the closest ones. (For more information on blocking in a painting, see page 42.) The distant tree-covered hills are rendered with a creamy mint green made with white, phthalo yellow green, blue, and magenta (for toning) along with muted purple-blue shadows made with white, blue, and magenta. Creating short brushstrokes with a small flat brush helps block in the small, variegated distant hillside trees.

4. Block in the bright highlights and hard shadows of the trees and grassland, using sap green for deeper greens, phthalo yellow green for brighter, sunlit areas, and muddled ultramarine blue, white, and green for filler mid-tones. If desired, magenta and orange can be used in small amounts to desaturate green or blue color mixtures for filler tones in the riverbank and tree line.

5. Continue working downward through the composition, using the green mixtures to dash in strokes of grass to the marshland foreground. Use short, vertical tick motions to indicate the upward pull of strands. Block

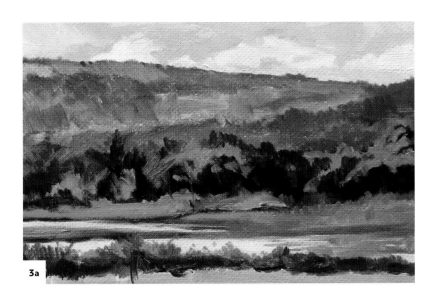

3a

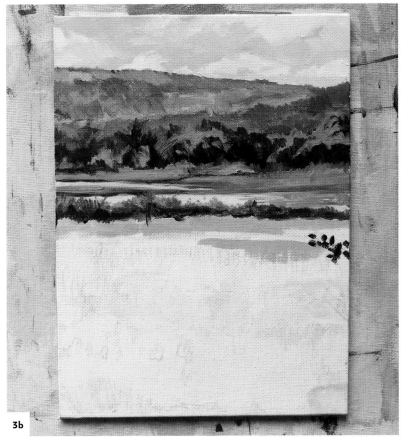

3b

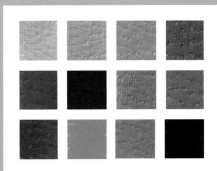

NOTE *Reference these color swatches for ideas for key hues found in this painting.*

in the purple flowers, using a mixture of white, ultramarine blue, magenta, and a touch of yellow to tone the hue.

6. Now that you have a solid initial layer of coverage, paint additional tick marks of color all over the composition. The contrast, shadows, definition, saturation, and paint opacity should increase here. Building layers of color at this stage is an essential part of how I create visual history in a painting, suggesting depth in the scenic foliage. Remember to include the dappled, deep emerald leaves on the right side of the piece. As you paint, pay attention to the pressure of your hand during brushstrokes. Lightly form the pointed ends of leaves and tapered grass tops.

7. Don't be frightened by this technique: take a clean, soft, midsized flat brush and lightly sweep over the greener areas of the painting. This gives a light, directional pull as it blurs the paint, so be mindful of the directional pull of your strokes. Softly emphasize the upward pull of grass and horizontal layering of the scene as you go. Apply enough pressure to blur the brushstrokes and fill paint gaps in the marsh areas. The look ends up being softened and glowing, and the painting is now ready for last-stage detailing and glazing.

8. Repeat the techniques in step 6, but this time with greater refinement of detail and form. Solidify your suggestive detail work with deep shadows, white and purple flower heads, yellow highlights on the green brush, and light aqua blue accents in the grass and distant hillside.

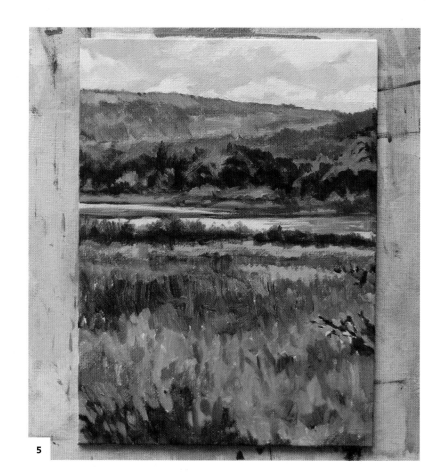

5

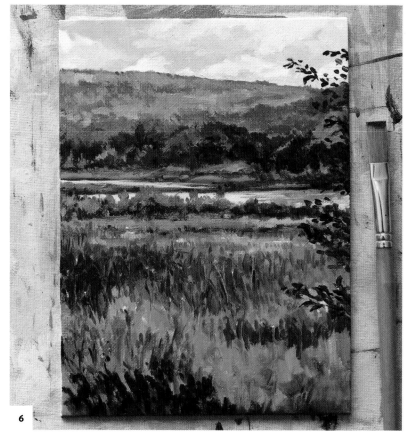

6

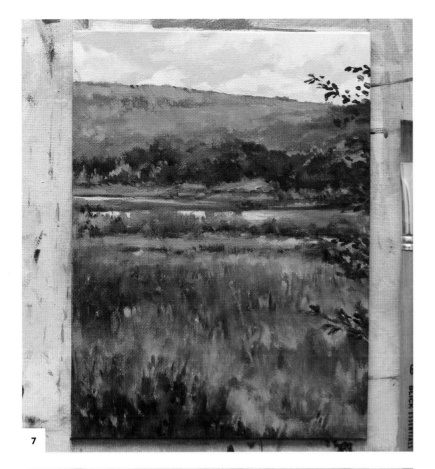

7

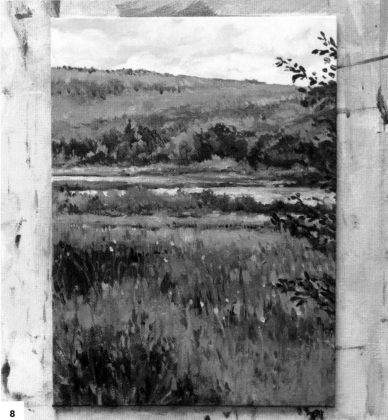

8

Emphasize the direction of the light source hailing from the top-left corner that sweeps over high points of the scene with warm yellows and contrasting shadows.

9. Finalize the image. Visually push the far hill back using soft additions of light blue at the top of the middle ground tree line. Scumbling in (see page 30) a broken, translucent light-blue haze here emphasizes saturation contrast between the middle and background tree layers while empha-sizing the appearance of atmospheric perspective.

Emphasize contrast in the deep green shadows with finishing color glazes; I used brighter, warm yellow tones to mimic the light hitting the brush and grass. I also defined the reflective water and bank lines more cleanly, using brighter white and light blue to carve negative space around the shore and trees. This helped the reflection stand out. Take the time you need to push out these final, beautiful details. (See the finished image on page 93.)

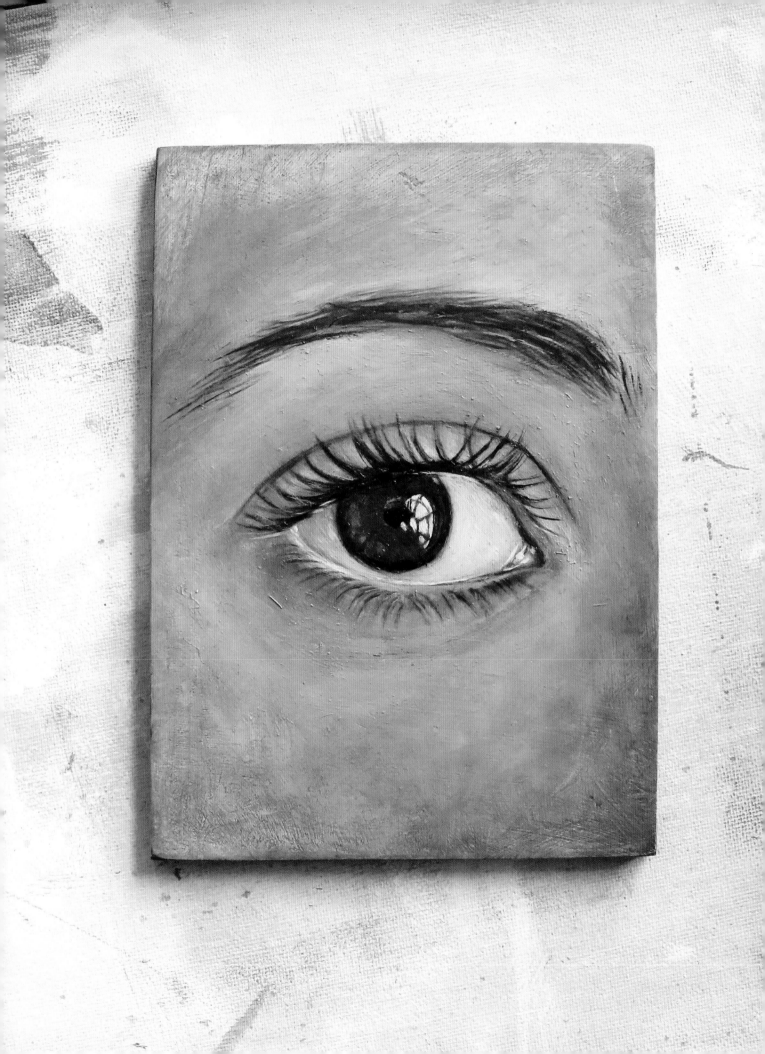

A CLOSER LOOK:
REFINING DETAILS

*In this chapter, you'll work on subject-specific projects
that promote deeper understanding of cloud, wave, and eye forms.*

At this point in your journey, you've painted a large variety of subject matter. Awesome work, artist. You're ready to dive into the details now.

In painting you'll sometimes approach compositions where the scene or subject matter is viewed from a distance. In these cases, using painting techniques that depict suggestive detail can give you lovely results. But what if you want to explore the intricacies of a single subject? Deepening understanding on how to depict texture, light, color, and form in close detail grants you access to technical knowledge that can elevate the work you do on any scale.

Besides the wonderful, holistic, technical growth benefits these next three projects offer, painting clouds, waves, and eyes is also just cool as heck. They're fun, impressive, and hopefully about to be accessible and approachable as well. Let's practice some moves that can impress both you and your viewers.

lesson 10:
CLOUD PAINTING

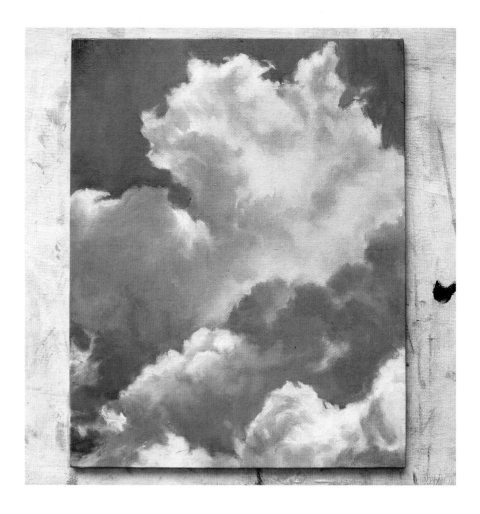

NOTE *I worked on an 8" × 10" (20.5 × 25.5 cm) canvas board.*

Clouds behave differently from other subjects in this book. While this palette is simple and the painting steps move through subtle layer building, cloud paintings are striking, with unique textural and light challenges. No two clouds or skies are the same. After you learn how to build basic structural integrity, you can lean into the organic, shifting nature of clouds and explore them more. Use my photo reference (see page 125) or your own, continuing with the photo through the end for more photorealism or leaning into the organic, shifting nature of clouds for some play. Let's try our hand at this.

1. Add these colors to the palette: white, phthalo blue, ultramarine blue, and magenta. Mix a simple light-blue color to start. I used white and a bit of both blues when laying down an initial layer of color, which helped me find my desired hue.

2. I began this painting without an initial drawing. I felt confident that I could establish my composition easily and quickly by blocking in the scene just with paint—try it. Block in the sky using a medium angled brush, leaving areas of the board exposed to help

2

3

NOTE *These swatches include the colors I used for this painting.*

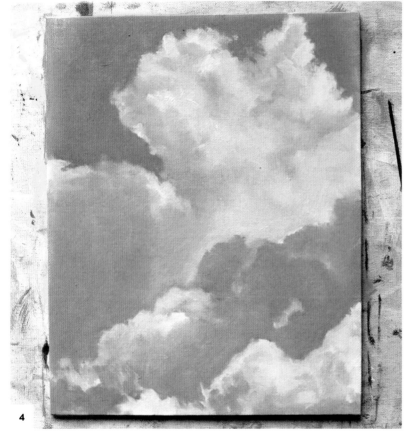

4

3. Continue to fill in the image, introducing white paint to the sunlit edges of clouds and into areas that catch reflective light, such as the upper-right portion of the cloud formation.

4. Phase out thinner, looser paint application and exposed canvas board in favor of layering thicker, creamier paint texture. Use white and phthalo blue for lighter, brighter areas and ultramarine blue for deeper, more purple-toned shadows. To create soft blends on the canvas, alternate between using your paint application brush for building layers and an additional soft, clean, dry brush used to lightly smooth paint and temper color transitions.

shape bright clouds in the negative space. Go for a thin, establishing layer and don't be concerned about building texture yet.

Cloud exteriors are light and wispy, but the middles are denser. Think about this as you layer more opaque paint into the sky and heavily shadowed middle ground cloud regions. When building up the thinner, lighter areas of clouds, use medium (such as Liquin) to apply a thinner, translucent blue.

TIP *If you like clouds as a visual subject, I recommend observing clouds more frequently for study purposes—and to unlock the secrets of the universe.*

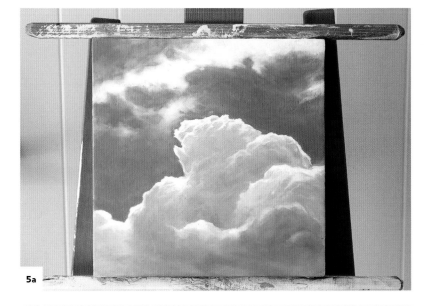

5a

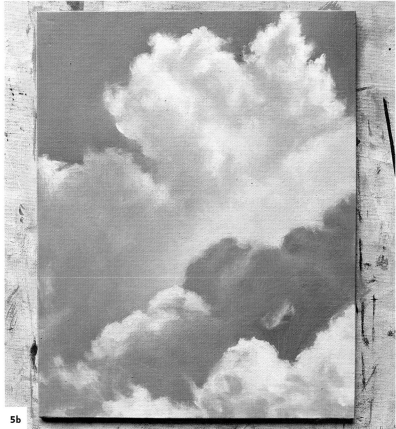

5b

5. Coming back to my painting after a night's sleep, I had a relatively dry, thinly layered painting and was ready to begin working subtle purple and pinky-beige colors into the clouds. Doing this, I referenced the sample image—one of my favorite cloud paintings I've made. If you notice, this painting incorporates standard blues and whites as well as subtle, iridescent pinks that seem to catch the sunlight and create a glowing atmospheric effect.

Referencing the swatch guide (see page 101), mix a muted purple using white, ultramarine blue, and magenta and a soft beige-pink with white and magenta, adding small touches of blue and cadmium orange to mute the pink tone. Find areas to add deepened shadow and sunlit warmth to the cloud.

6. Increase the drama of the image by pushing the contrast higher, layering deeper blues into shadows cast over overlapping clouds and blending them out to medium purple-blue

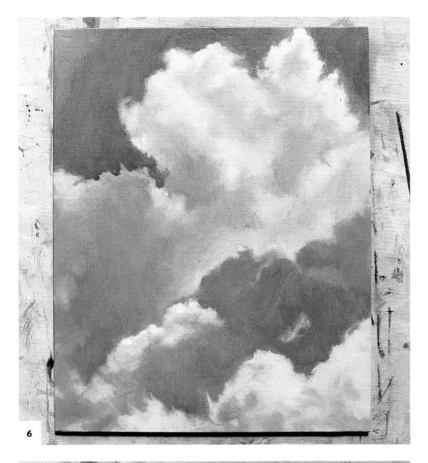

6

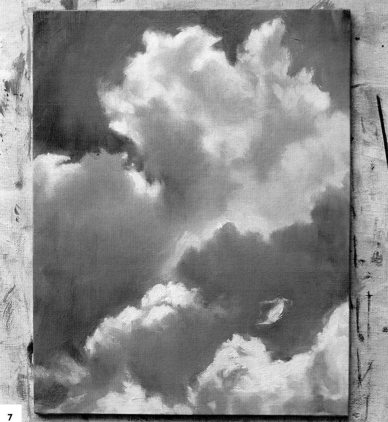

7

mid-tones. Apply color to deepen the contrast without worrying too much about finessing it. Detail work will come next.

7. Layer intentional, pure white paint onto sunlit cloud edges. Think about balance between softer edge-work and blends and the more defined areas of sun. Preserve selective crispness in some areas, while working with more subtle cloud layering and blending in interior spaces of the cloud.

8. In these final stages of the painting, step away from your work, observe it, and think about how you feel about the color, contrast, and composition. I shaped my cloud with glowing light coming from behind the middle cloud and gave the composition balance by adding a wispy white cloud piece to the lower left-hand region. Adding the white wisp helps circle the eye back into the image. (See the finished painting, page 100.) Without it, implied angles and lines created by the clouds seem to lead the eye off the corner. My mom always used to remind me of the importance of keeping the viewer's eye circling back through the composition, and the advice came to mind in this step. Thanks, Mom.

lesson 11:
WAVE PAINTING

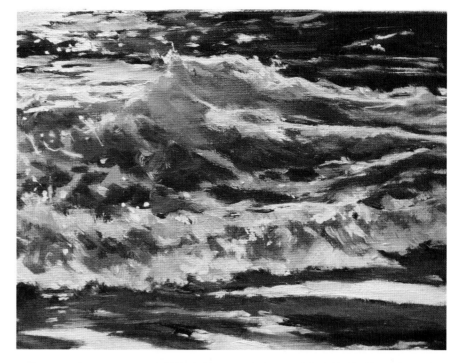

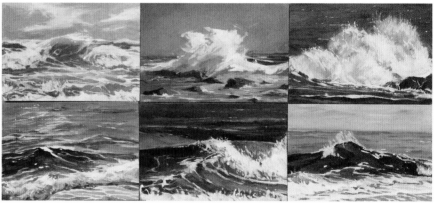

NOTE *I worked on a 5" x 7" (13 x 18 cm) canvas board.*

We've done a wave-replica painting, so what's different about this wave painting? Before, we focused on photorealism, and in this lesson, we'll dial back the technical drawing and precision in favor of a more loose, character-driven image. Make this painting less about exact photorealism and more about capturing movement, basic form, and visual impressions of the wave (see reference photo page 124).

Study these six small wave studies that I completed during a personal paint-a-thon that was focused on a loose, Impressionist style of painting. Try working without overthinking and lean into some of the knowledge you've built. Follow my steps and then play with your own character development of this wave. Leave it loose like I did or dive deep into high rendering and soft blending. The choice is yours.

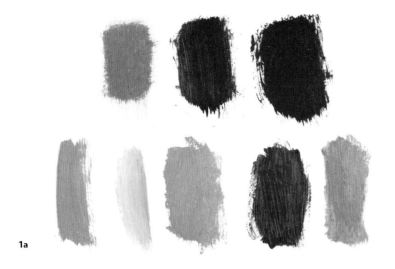

1a

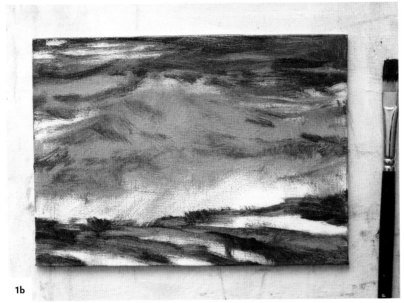

1b

1. Referencing the swatch guide, mix a yellow ochre color using yellow and burnt sienna. Add Liquin to thin the paint and selectively scratch the color onto the board. Think about blocking in major shapes, such as adding the yellow ochre mixture to the center of the composition and lightly to the base. Leave exposed white board in areas where you'll paint lighter sea foam later to block out the image.

2. Create a dark emerald color using sap green and ultramarine blue mixed with a small amount of white. Paint this over the yellow to shape and block in all the darkest areas of the wave. This dark color is mainly dispersed in the top and bottom strips of the image, with light amounts being used to begin creating shadowing in the center of the wave.

3. Next you'll work with shades of white and light blue. Mix white with small amounts of ultramarine blue to fill in light-colored negative space on the canvas. Note the lightest and brightest areas of the reference photo. Shiny areas on the top and bottom of a wave are whiter to indicate reflective light hitting the water, while middle portions of curling, shadowed foam are light, but not as bright.

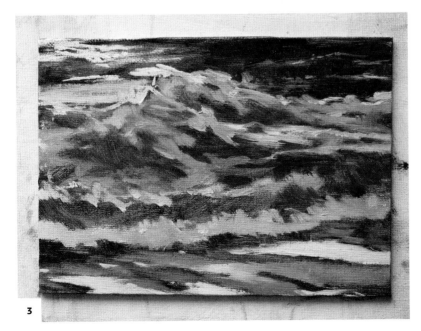

3

4. Use the deepened sap green mixed earlier and neutral blue-gray colors to build up mid-tones and heighten contrast and definition. Mix medium tones using ultramarine blue, magenta, and a touch of white. The dark emerald color will be useful to deepen the glassy water above and below the wave. Use this color also to shade lower regions of the curling wave.

5. Use white and light blues to add some sea spray around the wave crests and coming off of the rolling sea foam that's encroaching over the glassy water at the foreground of our image. White and light blue can also be added in the glassy foreground to emphasize the shine on the water. Use a smaller, pointed brush for this detailing.

6. Use sap green to fill out dark regions of the water that have a deeper green color glow. This is the final base on which you'll layer finishing details, so use it to push interesting hue and saturation.

7. Use pure white to add finishing touches to the painting (see finished image, page 104). White can be carefully and lightly painted on the high points of the sea foam or mixed with a small amount of medium to help soften blended paint in the mid-tones, but be sure to reserve the purest, brightest whites for sea spray and sun reflections. Preserving white for these areas is your best chance to achieve dazzling contrast against deep shadows.

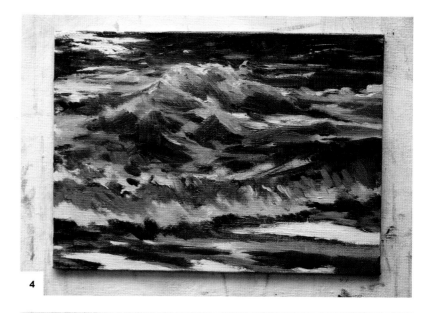

4

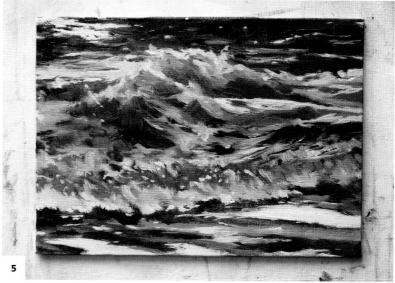

5

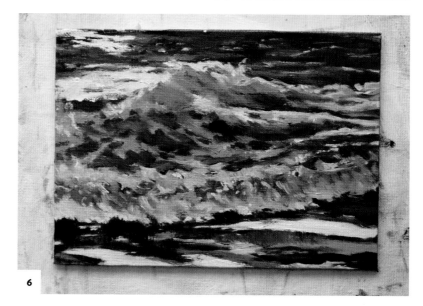

6

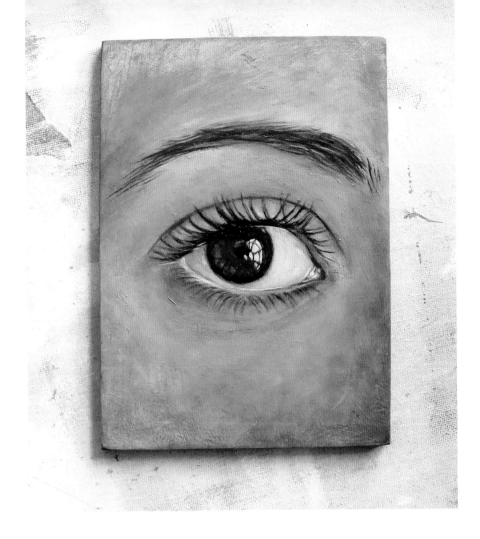

lesson 12:
EYE PAINTING

1

Let's get back to photorealism and high rendering for this lesson so we can discuss the intricacies of an eye—my eye (see reference photo on page 124)! Before discussing portraiture further in the next chapter, we'll dive into the eye's fascinating qualities and visual components. This subject has been explored by many budding and experienced artists, including me. A window to the soul, a colorful, encased mini-universe—we'll get deep on this one.

1. Prepare your surface by toning it with burnt umber paint diluted in roughly an even ratio with turpentine to achieve a fairly thin and deep, translucent brown. (This mixture works for toning other primed surfaces as well.) The paint thinner thins the paint and speeds drying time, depending on how much you use. Aim for creating a thin, relatively quick-drying, warm-toned surface upon which you'll build skin and eye tones. Leave the board to dry for a couple of hours in a warm, sunny spot; leave it overnight; or use a hair dryer to speed the process.

If you're doing a transfer drawing, be sure the painted surface feels dry enough to the touch to work on and use hairspray or fixative on the finished drawing.

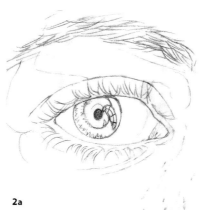

2a

2b

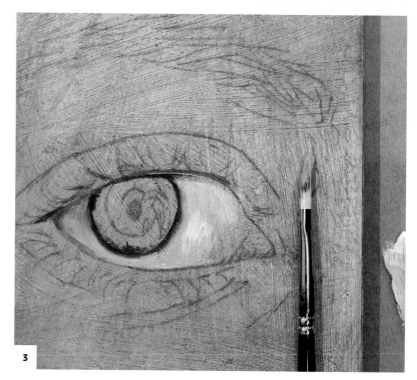

3

2. Begin your transfer drawing. Coat the backside of your photo using charcoal or a dark colored hard chalk pastel, able to stand out against the toned surface. I used a dark purple Prismacolor NuPastel Color Stick. Trace over the photo directly, sketching in relevant details. In my drawing notice the relevant line work that I included. You'll see naturally overlapping brow and lash hair, lightly outlined areas of highlight and shadow on the brow bone and upper eyelid, the eyelid crease, and the piece of skin between the bottom of the eye and bottom lash line (in the cosmetology world, this is called the waterline). In the reference photo, notice that in the eye's interior are the colorful rings of the iris, a black pupil, the arching light reflection of my studio window, and a fleshy pink inner corner.

When you draw, think of the structure of the pieces you're focusing on. Form is important to constructing the eye.

3. As you define the white of the eye, be aware that there are many more tones than simple white here. Using white, ultramarine blue, and black, mix a variety of cool blue shadows and off-white shades to round out the shape of the eyeball. The top lid and lash line cast a shadow onto the white space below, and the outer left corner of the eye is darker than the right corner (which sits closer to the light source), so paint accordingly.

4. Use burnt sienna, black, yellow, and orange to define the colors of the iris and pupil and the surrounding shadows created by the eyelids. Study your own eye in a mirror. Irises have a soft and smooth outer ring of color and inner colors that fan out from the pupil. The iris is actually a muscle that moves to constrict around the pupil in bright light and relaxes and dilates in lower light. Fanning color away from

the black center of the eye increases realism, as does adding a shine on the eye surface. Use black for the very center of the pupil and mix rings of brown and dark green to create a hazel eye. Work carefully and use a small brush and white paint to add details of shine and reflective light from the window, with minor light-green shine added above and below the pupil.

5. Remember the tips on painting varied white tones in step 3 as you finish rendering the white of the eye and move on to painting your eyelids. Because an eye is spherical you will see greater light hitting its central, more protruding portion. Place your lightest white near the center of the eye and fade into more blue-tinted shadowy edges; then let burnt umber outline the white of the eye and fleshy

pink inner corner. This will help shape the eye before moving on to the surrounding skin. Mix white, red, and burnt sienna to create a light-peach tone to be used around the eye. Cool, darkened fleshy shadows for beginning to define the brow bone curving into the bridge of the nose can be mixed by adding ultramarine blue and burnt umber to your flesh color.

6. Refine shadows and colors in the pupil, adding detail and contrast. Define thin, dark details such as the base of the upper lash line and the eyebrow hairs. Mix Liquin and burnt umber to a more fluid paint consistency, promoting of an easy, thin brush pull on individual hairs, and then add small amounts of light-gray mid-tone to highlight, soften, and fill in the denser, right side of the brow.

4a

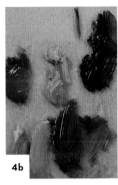

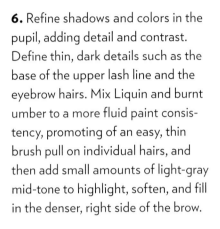

4b

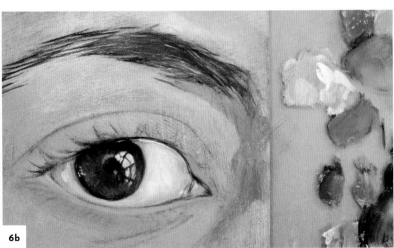

6a

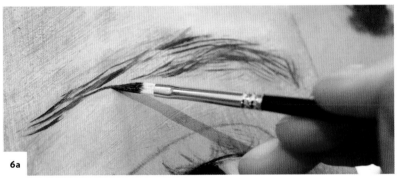

6b

7. Build up the skin tones and texture, increasing the opacity of the flesh surrounding the eye. Add highlights to the brow bone using white or a very light pinkish-brown color and shade and inset the lid crease with warm brown. Create a thick lower lid with a light line of flesh color directly under the eye and a darker shadow just beneath that where the lower lash line will go. Tint or shade the warm brown-pink base flesh tone with white in highlighted regions and add burnt umber and purple in shadows.

8. Paint the lashes using thinned burnt umber paint and a thin, small, pointed brush. Aim for subtlety. A cautionary lash tale: A common beginner mistake (and one I've made) is going too bold, thick, and crazy with the lashes. Think delicate and understated; think thinning, flicking, and light-handed curling movements with the brush to create tapered ends. If you mess up, you can always push them back by carefully wiping them away or layering flesh color over them and trying again.

9. At this point you could be done—I could have been done—but I chose to keep going. The perfectionist in me felt my flesh tones were underdeveloped, so let's keep going. Allow the paint to fully dry.

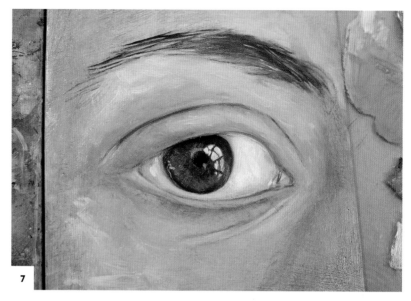

7

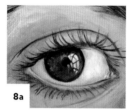

8a

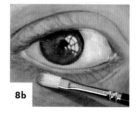

8b

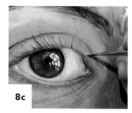

8c

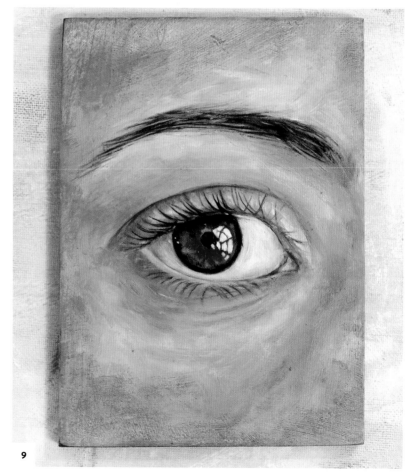

9

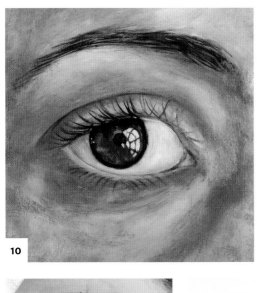

10

11a

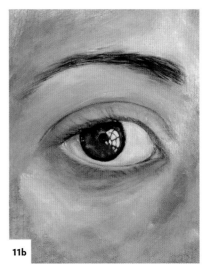

11b

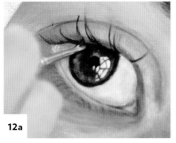

12a

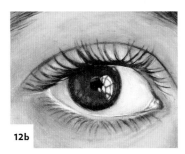

12b

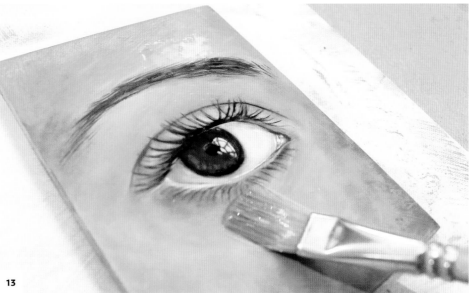

13

10. Apply a thin, semitransparent mixture of burnt umber and medium over the shadow areas to warm up the skin. This mixture functions similarly to a glaze but isn't as thin and fluid as glazes I might use to cover large areas without destroying significant underlying detail.

11. Mix light tan, a light-orange hue, and light phthalo yellow green hue on the palette. Use muted light yellow green tones to blend through and fill in the mid-toned and highlighted regions of the skin, smoothing out the warm glaze that was just added. Pay attention to brushstroke pressure, direction, and layering as you work, angling the brush to echo the flow of bone structure, hairs, and skin. Think of the flesh as curving and stretching over the underlying facial structure and create a skin of your own out of layered paint. These considerations help inform the structural appearance of the surrounding face.

12. Take one final pass at the lash line, working mindfully in this finishing step. Learning from previous attempts that I had to cover or wipe away, I made minimal, light, and curving sweeps using a small, angled brush and thinned burnt umber paint.

13. When the painting was completely dry, I applied a gloss varnish.

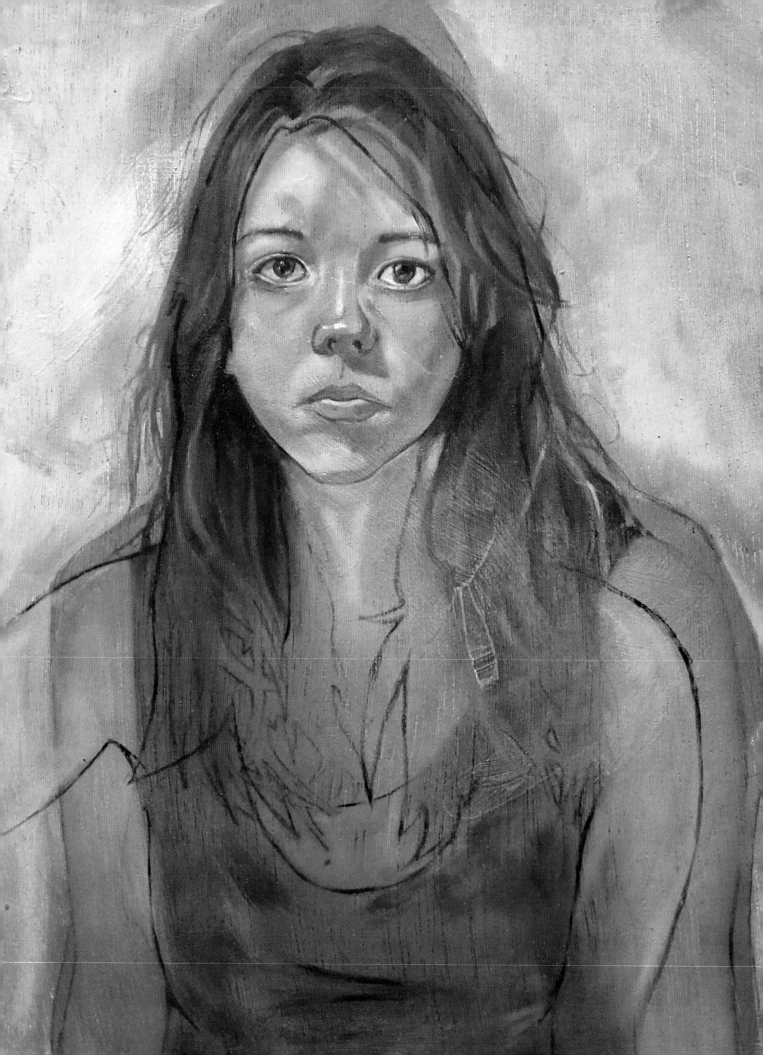

7

PEEK INTO PORTRAITURE

This chapter includes tips, tricks, and a detailed, doable portrait lesson to get you started in figurative work.

Wowza, what a ride this book has been so far with you. Let's end where I began my oil painting education—with the figure. My first painting focus as a university art student was portraiture (energetically spurred by my 2011 self-portrait shown here). After years of meandering through various subjects, portraits have recently become of interest to me again. Much can be communicated visually through faces and figures. I see portrait work as a key tool in any artist's tool belt. From our earliest found art, we see humans working in cave drawing and stone carving to depict human form. A long passed-on tradition that continues to grow as an art form, being able to render the figure is a connecting artist practice that can enhance personal work and open doors for sharing visual concepts.

My relationship with art and figures continues to evolve, influenced by the beautiful creations of other working artists. Recently my interest has been piqued by a blend of classical representational painting and contemporary, abstract, expressive work. I'm excited to see what new waves of artistic style we'll bring to figures as art history continues to be formed.

NOTE *This is a recent figurative work completed in 2020; Untitled Dancers, 2' × 3' (61 × 91.5 cm) mixed media and oil painting on canvas.*

lesson 13:
GESTURAL FIGURE DRAWING WARM-UPS

Gesture drawing here refers to a series of quick, posed figure drawings. While working through these warm-ups, prime your mind to look for curving arcs in the body, solid areas of bone, soft bends, hip tilts, weight shifts, and generalized shapes. In timing these practices, the hope is to strip away perfectionism and move the focus to denoting impressions and movement. Gesture drawing can feel awkward at first, but it will improve naturally with trust and practice.

WARM-UP 1

1. Complete six to ten (or more) one-minute gesture drawings. For your model, grab a partner to sit for you in timed poses (I used my nieces), go online to find free images of dancers or gesture drawing models to work from, or choose a movie or TV show that you can pause. These samples were made using Prismacolor NuPastel Color Sticks and colored paper, but you can use any drawing materials you have. Markers, chalk, crayons, or charcoal could be fun.

2. As you work, lay down guiding central lines to indicate a pose, head or hip tilt, and general shapes. Measure angles and distances in the air with your drawing tool or practice tracing through curves first in the air to guide your line placement. These don't need to be perfect—the minute will fly by. Embrace this creative constraint and have fun with the process, allowing experience to build and guide your choices.

WARM-UP 2

Draw a pose from life or a photo in three minutes. Then draw the same pose for three minutes, this time from memory. Do not use anything else to guide you.

WARM-UP 3

Complete three three-minute drawings of subjects of your choosing (drawing from life or using photos). Focus on overall form, guiding curves and angles, and drafting quickly and thoughtfully.

GESTURE DRAWING EXERCISES

EXERCISE 1: DRAW ONE POSE IN TWO TIMED SEGMENTS

ONE MINUTE: Draw gestural lines and angles in a light color. (I used a yellow Prismacolor NuPastel Color Stick on this and the next two exercises.)

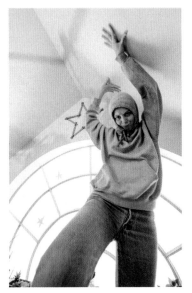

EXERCISE 1

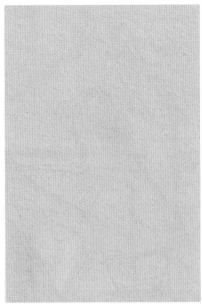

THREE MINUTES: Draw over your work in a darker color, trying to create fewer and simpler curving lines indicating movement and form. (I used a mechanical pencil on this and the next two exercises.) Mine feels jazzy.

EXERCISE 2: DRAW ONE POSE IN THREE TIMED SEGMENTS

ONE MINUTE: Draw gestural lines and angles in a light color.

THREE MINUTES: Draw over your work in a darker color, refining the image with simple shapes and guiding lines.

TEN MINUTES: Spend ten minutes finishing the drawing however you like. I continued to define shapes and shadows in pencil to practice sight drawing.

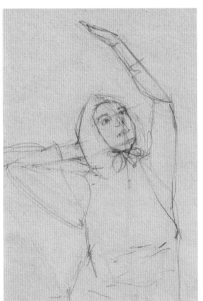
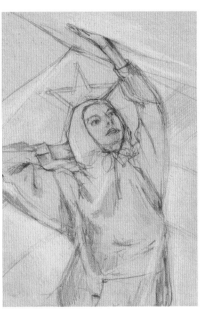

EXERCISE 2

EXERCISE 3: DRAW ONE POSE IN TWO TIMED SEGMENTS

THREE MINUTES: Draw guiding gestural lines and angles in a light color. Trust yourself and flow through the exercise.

TEN TO FIFTEEN MINUTES: Draw over your work in a darker color, refining line work and playing with style as desired. I hope you feel your understanding of gesture drawing growing as you finish working through this step. These warm-ups are great for practicing and getting into a mindset of life and free hand drawing.

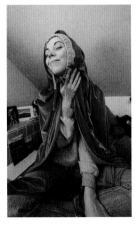

EXERCISE 3

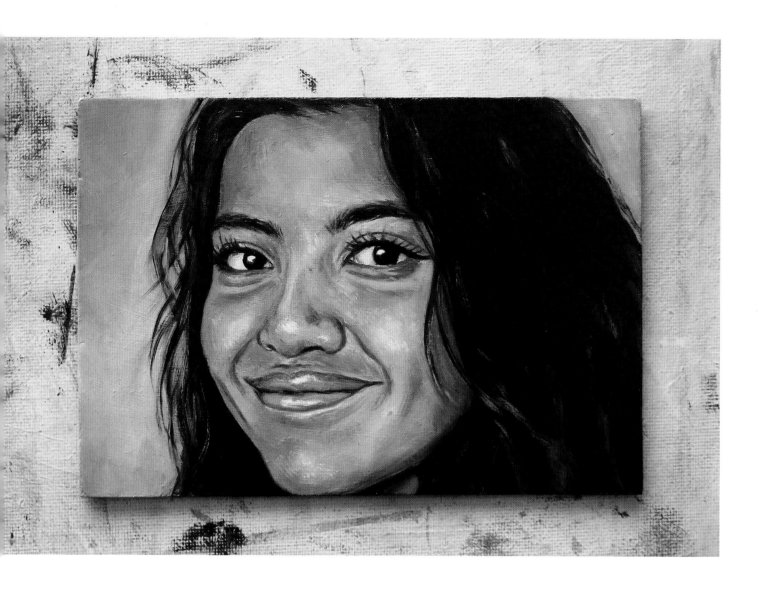

lesson 14:
PORTRAIT
OF PAUL

In this lesson, you'll work on a step-by-step portrait of my friend Paul. I'll reference portraits I've made in a similar style to this project and share process images of an unfinished first attempt I made at painting Paul, for additional insights and inspiration.

1. Begin with a transfer drawing. Coat the back side of the photo with a dark brown Prismacolor NuPastel Color Stick or something similar. As you trace over the photo, draw relevant details. Notice the choices I made to outline dominant features (the hair, face, eyebrows, eyes, nose, and mouth) as well as important details, highlights, and light shading. I was able to transfer pressure-sensitive shading as well as hard outlines, tracing in more heavily for bold, dark eyes and lighter for cheek shading. My previous attempt at this portrait made me work extra carefully through each step, including

drawing accuracy and detailing. A solid foundational image will increase your confidence in the following steps.

Remember to attach the image with two pieces of tape for greater security when checking work while tracing. Ensure the transfer is progressing well and that you're not missing any important defining marks, which are essential for a technical image like this.

Use hairspray or fixative to secure the finished drawing.

2. Reference the color swatch guide as needed. Paint the hair using burnt sienna paint diluted with medium. Add warm translucent brown layers for now, thin enough to still visibly see the drawing underneath. Darker, thicker hair will be added later, with touches of this initial brown poking through. For the skin color, create a peachy-brown with a mix of white and burnt sienna. For the eyebrows and darkest facial creases, use burnt umber and darken the pupil and lash line with a touch of burnt sienna. Work lightly in this layer, building a monochromatic base so contrast can form. Define Paul's facial features and bone structure by building in shadows, mid-tones, and leaving exposed white board where there are highlights. Highlights will all sit at the highest points of her face: a touch on the forehead, the bridge of the nose, the apples of the cheeks, the chin, and the shine in her eyes. Facial shadows should deepen in areas curving away from the light.

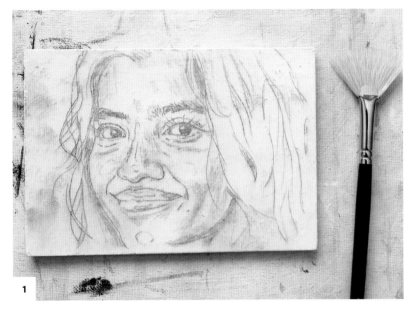

1

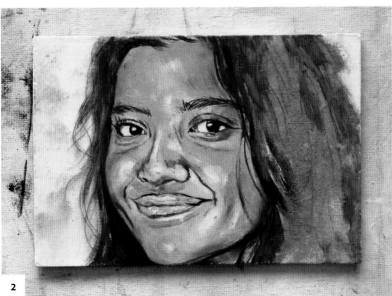

2

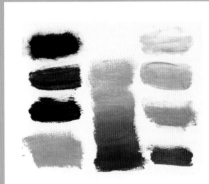

NOTE *Use this paint swatch as a reference for mixing colors.*

3. Use soft, sweeping, waving brush-strokes of black paint to form Paul's hair. Use a small brush and black paint to deepen her eyebrows, pupils, lash line, nostrils, lip center, and the shadows under her jaw. Leaving exposed areas of burnt sienna in her hair will reveal warm browns.

4. Paint around the flyaway hairs with white paint, using edgework in the negative space to achieve thin hairs. In this step, you can use careful, opaque paint marks to define thin hairs, then lighter, more blending motions to soften edges where the hair and background meet. Allow some black paint to mix with white for a light-gray background color and touches of cool highlights near the crown of Paul's head.

5. Continue developing Paul's skin in areas that are in highlight and shadow using mixtures of burnt sienna and white. Use small amounts of magenta and ultramarine blue to make a pur-ple-pink color for her lips as well as for shadows on the right side of her face and hairline.

3

5

NOTE *These portraits were done in similar styles; both are tightly cropped, with a clean background, and are photorealistic. I started with simple blocked-in first layers (shown in the samples), build-ing up those layers to create highly rendered and contrasted images. I decided to use a similar editing style for my samples when preparing my reference photo of Paul for this painting (see page 125). In times I want to amp up my confidence, a strong, clear reference photo guide and game plan for rendering style are reliable tools I use to prepare for success.*

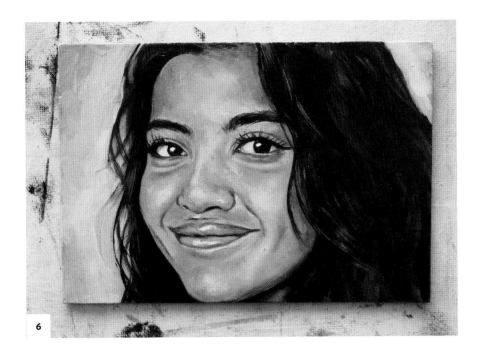

6

6. Use colors from step 5 to build up the flesh tones. A light, neutral purple-pink color can be used to transition mid-tones between the warm brown skin shading and the highlighted points of the face, seen on her cheeks and forehead. This color can be used as well to layer the background and add light sweeping highlight definitions to hair strands. Selectively placed highlights, made with light pressure and the naturally segmented bristles of a small flat or angle head brush, add suggestive details and texture to the hair.

7. Deepen the hair and darkest shadows with black.

Warm up and deepen the mid-range skin tones with a mix of white and burnt sienna, starting in highlighted areas and extending into the deepest shadows. Use pure white only on the shine in the eyes, the nose tip, lips, and sparingly on facial high points for maximum impact.

Build opacity in the background and areas of shininess in the hair with lilac purple-blue hues created with a mix of white, ultramarine blue, and a small amount of magenta. Lightly graduate the background color from lighter just behind Paul's hair, to darker at the edges for a more dramatic studio light effect. (See the finished image on page 118.)

Awkward Paintings and the Skill Gap

Wisdom is gained from all experiences, including ones that go well and ones we struggle through. Not every painting will go as planned, and because of a phenomenon called *the skill gap*, often our idealized taste sits apart from our current capabilities. This is all part of being an artist!

After working on this ultimately abandoned painting endeavor, I learned I wanted to work more carefully in each step of my next attempt, particularly in my paint application and color choices. Due to some ill-planned moves, I slowly lost footing with my drawing and with color. The main casualties were distorted eye shapes and a blank gaze made of misplaced shadows and marks. Ultimately I felt I had lost a clear hold on teachable steps I could share. I worried I couldn't fix the portrait in a satisfactory way for this book, so I made the difficult decision to begin again.

Embrace joy in learning and practice. An everyday creative practice is built in humble, appreciative steps. Big leaps and achievement badges are great, but, as they say, life is what happens while you're busy making other plans. An artist is made in proud achieving moments as well as in enduring, monotonous, and awkward ones.

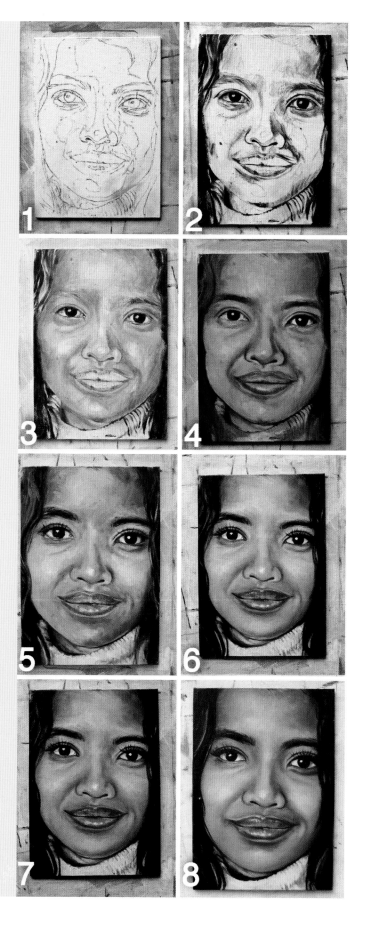

REFERENCE IMAGES

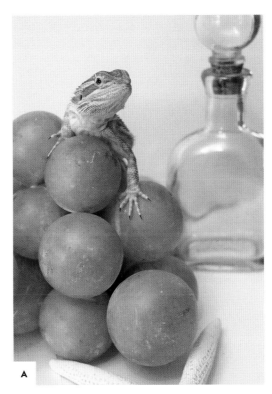

A

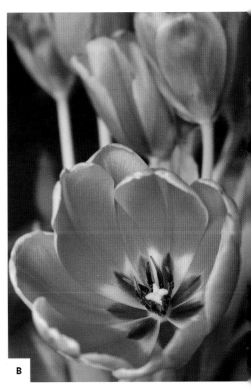

B

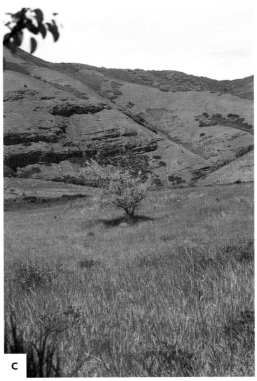

C

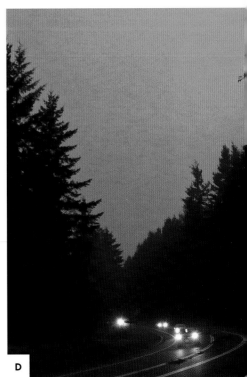

D

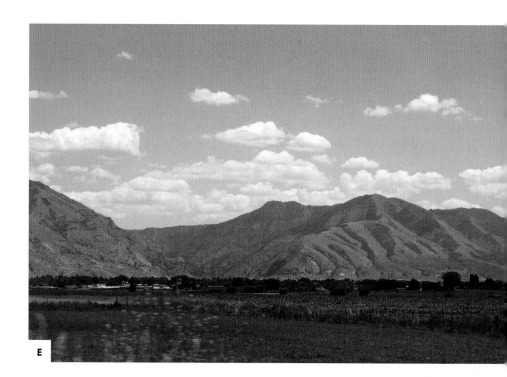

E

H

I

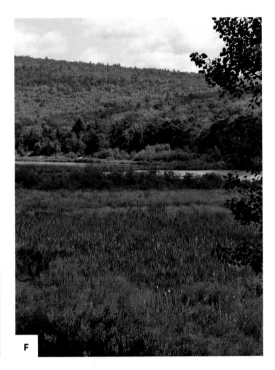

F

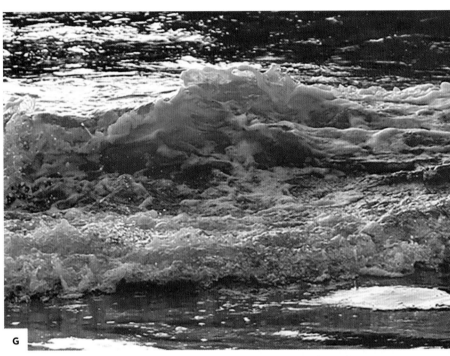

G

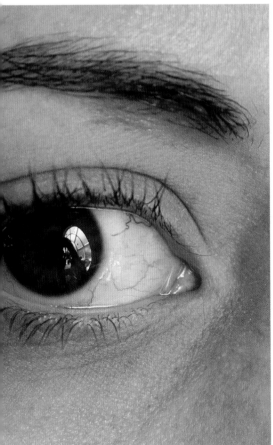

J

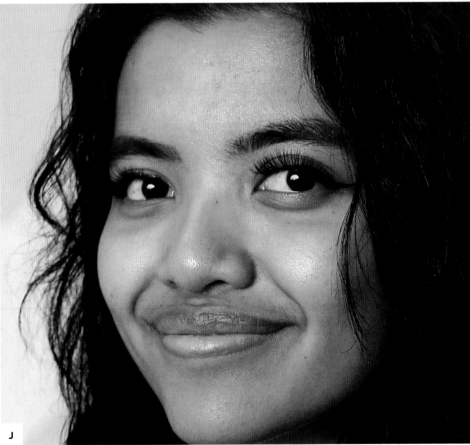

ACKNOWLEDGMENTS

I'd like to thank my friend Paulina Sovanny for modeling for the portrait painting. I'd also like to thank my incredible photographer friend Stacie Buhler for her photographs, which include the portraits of Hoodie and me, found on the gesture drawing project, cover, and this page; my family and friends for their support, hype, and feedback along the way; and my editor Jeannine Stein who was a kind, helpful, and encouraging advocate/contributor for making this book happen. Thank you!

ABOUT THE AUTHOR

Robin Sealark graduated with a bachelor's degree in fine arts and an art education certification from Brigham Young University in 2013. She spent her undergraduate years specializing in oil painting and hyperrealistic portraiture, but shifted her focus to landscapes, seascapes, and skies over time. Growing up on Long Island and exploring Utah over the last ten years inspired her to bring dramatic natural light and beauty to her paintings. Robin has established strong followings on Instagram and YouTube, where she frequently posts her work, process videos, tips, tutorials, relatable sketches, and advice for creatives. Through her personal work and teaching, she seeks to emphasize the idyllic beauty found in all subject matter through deepened observation and a discerning artist's eye. Her shared projects and educational resources aim to create accessible paths to the basic painting and drawing techniques, materials, and tools that make creative exploration and fine art rendering available to anyone. There's no gatekeeping here! Robin believes that a healthy, creative life is something everyone can access with full breaths, positive community, art appreciation, education, and regular practice.

INSTAGRAM: @robinsealark
YOUTUBE: Robin Sealark
WEBSITE: robinsealark.com

INDEX